BUDDHIST SYMBOLS
IN
TIBETAN CULTURE

BUDDHIST SYMBOLS
—IN—
TIBETAN CULTURE

An Investigation of the
Nine Best-Known Groups of Symbols

Loden Sherap Dagyab Rinpoche

Translated from the German
by
Maurice Walshe

Foreword by Robert A. F. Thurman

Wisdom Publications

WISDOM PUBLICATIONS
361 Newbury Steet
Boston, Massachusetts 02115
USA

Original German version:
Buddhistische Glückssymbole im tibetischen Kulturraum
© Eugen Diederichs Verlag, München 1992

Library of Congress Cataloging-in-Publication Data
Dagyab, Loden Sherap.
 [Buddhistische Glückssymbole im tibetischen Kulturraum. English]
 Buddhist symbols in Tibetan culture : an investigation of the nine
best-known groups of symbols / Loden Sherap Dagyab Rinpoche ;
translated from the German by Maurice Walshe.
 p. cm.
 Translation of : Buddhistische Glückssymbole im tibetischen
Kulturraum, 1992.
 Includes bibliographical references.
 ISBN 0-86171-047-9 (alk. paper)
 1. Buddhist art and symbolism—China—Tibet. 2. Buddhism—China—
Tibet. 3. Tibet (China)—Religion. I. Title.
BQ5115.C5D3613 1995
294.3'437–dc20 95-35742

ISBN 0 86171 047 9

00 99 98 97 96
 6 5 4 3 2

Designed by: L·J·SAWLit

Illustrations p. 98 by Robert Beer

Typeset at Wisdom Publications in Diacritical Garamond and LTibetan
font families designed by Pierre Robillard.

Wisdom Publications' books are printed on acid-free paper and meet the guidelines for permanence
and durability of the Committee on Production Guidelines for Book Longevity of the Council on Library Resources.

Printed in the United States of America.

CONTENTS

CONTENTS

FOREWORD

I AM HONORED AND DELIGHTED to write a note about this wonderful and useful book on Buddhist symbols by my old friend, the Venerable, I have to say, Dagyab Rinpoche. Though I have known Rinpoche for thirty-one years, in this book I hear for the first time his strong authorial voice. I have kept up with his works, but due to my poor German, I could not hear him as well in that language; he is of course fully proficient in it. Now, thanks to this excellent English translation, I can hear him clear as a bell.

Though he purports to be about the modest business of elucidating common symbols in Tibetan culture—the Eight Symbols of Good Fortune and so on, he simply and powerfully puts forward a theory of reality, a vision of life and its real purpose, and then fits his task into this big picture and bold design. He accomplishes these noble tasks with lucidity and sincerity, and with a light touch of ironic humor that leaves the reader in a pleasant space of lightness and ease. I am impressed.

Rinpoche gives a clear picture of the Tibetan scientific description of reality as being empty of intrinsic existence, which means that each thing lacks isolatable essence, existing only as utterly interrelated with every other thing. He evokes for us how different that is from the real-time space and gravity of the Western materialist reality, where each ego and thing stands atomistically as a thing-in-itself. He shows us that acknowledgment of such a reality gives Tibetans, whether consciously or unconsciously, a sense of freedom in their way of being, in the sense that an empty, desubstantialized, thoroughly relativistic reality has room for the various conventional realities of different people. The Tibetan view is thus not nihilistic, but is a profound insight that underlies a rich creativity.

He then introduces an entirely new dimension by employing the Indo-Tibetan concept of *chü* (Tib. *bcud*), meaning literally "essence," but used untranslated by Rinpoche to convey something like "quality," "energy," "orgone," "zest," "zing," "heart," or even "soul." In all my years of working with Tibetan thought, I have not heard this term—*chü*—used so creatively

by anyone else. It seems utterly appropriate! He perfectly captures the rich, colorful, invigorating flair of Tibetan life with his description of the presence of this "essence," "quality," "soul" which saturates it. And he gently reflects to us the utter lack of it in most corners of our drab, humdrum, industrial life-world. In this way he solves the dilemma of how to imagine old Tibet, the civilization that materialists and modernizers describe as backward, feudal, superstitious, religious to a fault, and spiritualists and romanticizers describe as a primitive paradise, Shangrila, spiritually sophisticated, and deeply devout. Old Tibet was a human society, and had its faults, no doubt, yet its people were mostly friendly, cheerful, in touch with the unseen and yet vitally alive and zestfully earthy. The point is, they could cope with hardship, imperfect infrastructure, imperfect people and institutions, and still love their way of life.

They have certainly shown they can cope with the most horrible kind of oppression modernity has frequently dished out—homicidal invasion, spiriticidal thought-reform, ecocidal exploitation, ethnocidal colonization, and genocidal assimilation. They continue to suffer this kind of treatment to this very day; yet they remain, for the most part, nonviolent, hopeful, cheerful, and constructive; "they" meaning from His Holiness the Dalai Lama or Dagyab Rinpoche in exile down to the simplest peasant woman, driver, nomad child, or beggar in Tibet. They seem to maintain some touch with "essence energy." Mao's worst efforts at thought-reform, civilizational lobotomy, failed to eradicate the Tibetan *heart* and *soul*.

So Tibetans must have something subtle which we generally lack, something good we are attracted to and which perhaps might even be vitally important for us to restore "soul-quality" to our postmodern lives of not so quiet desperation. Rinpoche suggests this more indirectly than I do here—which I should do, since I am not Tibetan but am member of one of the many tribes that are letting the Tibetan holocaust continue in its latest modality. A purpose of our lives is, if not to attain the unlimited wisdom and satisfaction of full enlightenment, at least to recover the "essence" in life, convince ourselves that it really is worth living, and therefore that we should make the effort to stop the mechanical processes we have unleashed that will definitely soon make life unlivable on this planet for everyone, including other animals with the other humans.

Here fits the purpose of this book on Buddhist symbols. Something about the Tibetan way of imagining their lives is precious. In the ultimate voidness of free reality, Tibetans have long been steeped in the nonconventional tantras or spiritual technologies of creating more enjoyable realms of

living. The key tool of this continuous reinvention of viable life-realms is the symbol. In Rinpoche's lucid image, it is the catalyst in the holographic component that builds up the positive, the beautiful, the good. So Rinpoche gives us a catalog of these tools, the Eight Symbols, the Eight Bringers of Good Fortune, the Seven Jewels, the Secondary Jewels, and so forth, up to the—my favorite, a bit of Tibetan imaginative genetic engineering—the Three Symbols of Victory in the Fight against Disharmony (the eight-legged lion, the fur-bearing fish, and the sea-monster conch). He gives us a subtle set of keys to personal good fortune and a more livable society.

These symbols are found in Tibetan art, as studied by art historians, who will be grateful to this work, but also on teacups, belts, furniture, saddles, bridles, and all sorts of implements, clothing, and buildings. They are the subtle, creative slivers of the colorful hologram of the uniquely Buddhistic culture of Tibet. I am very grateful to my friend and colleague for bringing out this careful work on them, and sharing his profound and generous insight. Rinpoche is as Rinpoche does, as the old saying goes. This is a precious book.

Robert A. F. Thurman
Jey Tsong Khapa Professor of Indo-Tibetan Buddhist Studies,
Columbia University; President, Tibet House New York.

PUBLISHER'S ACKNOWLEDGEMENT

THE PUBLISHER GRATEFULY acknowledges the generous help of the Hershey Family Foundation in sponsoring the printing of this book.

PUBLISHER'S NOTE

THIS BOOK WAS ORIGINALLY PUBLISHED in German in 1992 as *Buddhistische Glückssymbole im tibetischen Kulturraum: Eine Untersuchung der neun bekanntesten Symbolgruppen* by Eugen Diederichs Verlag, München. In this new edition, we at Wisdom Publications have endeavored to present a clear and readable English translation while remaining faithful to the German original. In a few translated passages where the editors had access to the Tibetan source material, the wording has been cast into a form more natural to English; elsewhere, the wording of the German edition has been closely followed.

In the original edition, Dagyab Rinpoche often uses the past tense in referring to the employment of symbols in (Old) Tibet, particularly in reference to their use in monasteries. In this English edition, we have generally preferred the present tense; still, it is important to mention that much or most of the traditional religious culture in Chinese-occupied Tibet has been suppressed and, therefore, contemporary use of these symbols within a religious context applies mostly to Tibetan communities in exile.

Tibetan names and terms that appear in the body of the text have been rendered phonetically. In the notes, glossary, bibliography, and in paren-thetical references, however, Tibetan words are romanized according to the system described by Turrell Wylie ("A Standard System of Tibetan Transcription," *Harvard Journal of Asiatic Studies*, Vol. 22, 1959, pp. 261–7), except that capitalization is applied to the first pronounced letter, or to the root letter when there is no obvious phonetic initial. Sanskrit has been transliterated according to the standard, internationally recognized system.

Titles of frequently cited texts are translated into English, with the Tibetan and Sanskrit given at first occurrence. For the convenience of specialists, selected passages from the Tibetan primary sources can be found in the notes. A glossary lists English translation equivalents for the corresponding Tibetan and Sanskrit terms.

In conclusion, we at Wisdom Publications would like to heartily thank Ven. Dagyab Rinpoche for his unfailing support, availability, and assistance

during the translation, editing, and production of this book; Ven. Regine Leisner, Rinpoche's secretary, for her swift and helpful replies to our endless queries; Maurice Walshe, for his overwhelming generosity and skillful expertise in rendering this fascinating manuscript into English from the original German; and Robert Chilton, for his painstaking editorial and research work in polishing and refining this English edition of Dagyab Rinpoche's exceptional work.

PREFACE

FOR MORE THAN A THOUSAND YEARS, Tibetan culture has been imbued with
and characterized by a powerful spirituality in which Buddhist studies and
profound philosophical insight, intensive meditation practice and simple
superstition, have peacefully coexisted side by side. Religious practice
extended to nearly all areas of private and public life, and it was by no
means at home only in the monasteries, but also in the houses of farmers
and traders and in the tents of nomads. A nearly indescribable unique
atmosphere was prevalent in Tibet, a special spiritual climate, which was
hardly perceived consciously by us Tibetans. Only after the monasteries had
been destroyed, and many of us met again in exile, did we come to
acknowledge how different is life in other countries, especially the countries
of the West, from what we had known.

Tibetans are not inclined to sentimentality. It is not too difficult for
most of them to find their feet in a new existence. Neither has it been nec-
essary for them to look back continually and be nostalgic about past happi-
ness. But we naturally have been making comparisons and considering the
differences.

First of all, it struck us that people in Western countries obviously had
certain preconceived notions about Tibet. Even today—in spite of tourism
and abundant information provided through the media—there seems to
exist an image of Tibet as the mysterious land of snows, endowed with
magic and mysticism. We gain this impression, for example, when we
observe the way in which elements of Tibetan culture are used in advertis-
ing, that is, in an area where psychology plays a great role.

So what can we say about this mythical image of Tibet? Although com-
posed, in part, of dreamy, fanciful projections—does it contain a kernel of
truth? If we concern ourselves with these questions, we encounter, among
other things, the odd invention of a word—"Lamaism"—which, unfortu-
nately, can still be found appearing in the literature here and there. There
are some who attribute fabulous supernatural abilities to the lamas, while

there are others who smile with pity at such notions, regarding them as products of the overactive imaginations of superstitious crackpots. For both, a blurry, vague conception of what the lama really is prevails; thus, there is hardly need to mention that their understanding of Indo-Tibetan Buddhism—apart from which Tibetan culture would be unimaginable—is likewise hazy and incomplete.

Now, if we were able to erase this deficit of information, what would happen? Would the fascination with Tibet come to an end, or would it be newly invigorated? In this question lies the challenge that I would like to take up in the present work: to provide some facts about the Tibetan symbolic world while also describing, at the same time, Tibetan thinking and sentiment. I shall try to make the origin and background of some of the best-known groups of symbols understandable to Western readers, drawing upon both my perspective as a Tibetan and a lama, and my experience of having lived in Germany for more than twenty years.

Therefore, in the first part of the introduction, I will deal in detail with the foundations of Tibetan culture and thought. As for the usage of symbols within that frame of reference, let me say from the outset only the following: we do, naturally, use symbols in order to express portions of our outer and inner reality in concentrated form and to remind ourselves of particular links of significance or meaning. But not only to express and remind—what we are dealing with here is an act of influencing future reality, neither more nor less. How we visualize this, and how it works, will be the subject of closer scrutiny in the second part of the introduction.

In referring to symbols, we use different terms in Tibetan according to the point of view. The best known are *tak* (*rtags*, meaning "omen, sign, or indication"), *tsenma* (*mtshan-ma*, meaning "distinguishing mark"), and, above all, the concept of *tendrel* (*rten-'brel*), which embraces such a profusion of possible meanings and associations that it cannot easily be rendered with a single word. It is made up of *ten* (*rten*), meaning "support," plus *drel* (*'brel*), meaning "dependence, conditionality," and thus indicates that all phenomena are linked with each other and dependent on each other. Therefore, nothing exists on its own, by its own power. This "emptiness of inherent existence" (*stong-pa-nyid*, Skt. *śūnyatā*) is an essential feature of the Buddhist teaching, and we shall have to deal with it in some detail.

Whoever has, according to the Buddhist view, realized emptiness and conditionality, grasps reality "as it is," free from distorting concepts. With the extinction of all illusions and erroneous concepts, suffering also disappears. No wonder, then, that in the context of Tibetan Buddhist culture, a

mere reminder of emptiness/conditionality is considered fortunate in the highest degree.

It will, therefore, come as no surprise that the expression *tendrel* is not only used as a technical term in philosophical discussions, but has also found its way into everyday speech. In the latter usage, it means a fortunate chain of circumstances, a sign of good fortune to come, a good omen, and so on. The expression is also used in reference to particular actions, objects, pictures, or forms of expression which are more likely than others to designate conditions related to desirable positive results, to make these conditions clear or to represent them.

Of course, at a fundamental level, all phenomena, meaning all colors, shapes, movements, and sounds, all qualities of smell, taste, and touch—in short, all elements of our reality, are *tendrel*. Ultimately, we can utilize absolutely anything to call to mind conditionality and emptiness, together with all their consequences. This becomes particularly evident with the Five Qualities of Enjoyment (see p. 99). All the same, it is assumed that certain objects are more "loaded" with significance than others. The nine groups of symbols chosen for this study consist of such objects, and we shall thoroughly investigate their origin, meaning, and usage. In Tibetan culture, they are often used as symbolic gifts on important occasions such as weddings, births, the beginning of a journey, or the New Year, with the object of producing a positive effect. In this sense, the simple act of sending a greeting card bearing these symbols can be *tendrel*. It was only in exile that the Tibetans acquired from other nations the habit of sending preprinted greetings cards. The subject matter is generally taken from traditional Tibetan art, especially religious art. A few such cards, from among those that I have collected during the last thirty years, are reproduced here as examples, with commentary. They provided the inspiration for the present study.

Thus *tendrel* can be both a symbol, in regard to a desired effect, and an omen, in regard to a cause or an accompanying circumstance which is now manifesting and which is to be brought into connection with a subsequent effect. In order to do justice to both these points of view, I have, according to context, rendered *tendrel* as "symbol" or "sign." In describing the different groups, I shall also give examples of the use of such signs in rituals and the results achieved. Thereby, with the added support of the original Tibetan texts supplemented by commentary, I hope to convey at least a little of the fascination they have produced.

Owing to the mass of material, especially of original Tibetan texts dealing with *tendrel*, I have restricted myself to the best-known groups of

symbols, omitting individual symbols not connected with one of the groups treated here. The texts relating to the symbolic interpretation are each translated or paraphrased—and commented upon—at the appropriate place, with selected quotations given in the notes. As far as possible, the Sanskrit equivalents have been given for the Tibetan terms, taken either from the *Great Volume of Precise Understanding* (*Bye-brag-tu rtogs-par byed-pa chen-mo*, Skt. *Mahāvyutpatti*)[1] or, with reservations, from Tsepak Rigzin's *Tibetan-English Dictionary of Buddhist Terminology*. The Sanskrit terms appearing in passages from the Tibetan texts, for instance in sacrificial mantras, are given unchanged in Tibetan spelling.

As regards my methodological approach, I would like to say that this study was originally conceived and, as far as the descriptive part is concerned, carried out as an investigation into symbology on Western academic lines. However, in the course of my work, various questions arose concerning the meaning and employment of symbols, which could not be satisfactorily answered within this framework. After careful consideration of the various factors, I decided finally to supplement the explanatory part with information derived from my own cultural background, the centuries-old Tibetan Buddhist tradition. In order to present this material in the same way I received it, I have intentionally and expressly refrained from adapting it to conform to Western scientific notions.

This study emerged from the *Symbol-Projekts* of the Central Asian Special Research Field of the University of Bonn. I would like to take the opportunity of thanking all those who had a share in its making. My special gratitude goes to Prof. Dr. Klaus Sagaster, who assisted its progress with numerous references.

<div style="text-align: right">

Loden Sherap Dagyab Rinpoche
Bonn

</div>

BUDDHIST SYMBOLS
IN
TIBETAN CULTURE

INTRODUCTION

ESSENTIALS OF TIBETAN THOUGHT

THE TEACHINGS OF BUDDHISM, the foundation of Tibetan culture, have been presented and commented on in so many publications, particularly over the past twenty years, that I can limit myself here to a few key points. Buddhism is a system of explanations and practical methods directed at the ending of suffering. The practitioner attains this goal by means of ethical behavior—refraining from causing harm to any living being, even the tiniest insect—and by meditative absorption and profound insight into the nature of reality.

If I now ask myself what, compared with Western thought, is particular to Tibetan Buddhist thought, I immediately come up against the different concept of reality. The Tibetans think differently about themselves and the world, both about the origin of the real and about the position of the individual within it.

Although Buddhism has always been counted among the world religions, it is still not settled whether we can properly call it a religion in the usual sense or not. It seems to me especially important to point this out here. Precisely when we are concerned with our concept of reality, we ought perhaps to refrain in the first instance from using the word "religion," to ensure that we do not make the mistake of supposing that we are concerned with *faith* rather than *knowing*.

Conventional Reality

According to our view, a firmly established reality existing as a substantial unity in space and time does not exist. Every phenomenon, every object of whatever sort that greets our eyes, consists in its nature simply of the momentary, passing interplay of physical and nonphysical factors, summarized as "causes and conditions" (*rgyu-dang rkyen*). These are enumerated as: (1) the presence of separate *components*, down to the finest particles and sub-particles in their momentary arrangement, and (2) the *processes* of composition or formation, or else the subsequent disintegration of every single

object; further, (3) the *observer* as perceiving subject, and (4) the *perception-process* of grasping, identifying, and naming. Accordingly, there is nothing, absolutely nothing, that we can put our finger on and say: "Here we have the real, inherent essence of an object, here is the 'tableness' of the table, the 'treeness' of the tree, the 'Tomness' of Tom."

All phenomena are subject to this conditional arising, this manner of existing in dependence. As we briefly mentioned in the preface, the Tibetan term for this is *tendrel*. Interestingly, this word is made up of *ten* (*rten*), meaning "support, basis," and *drel* (*'brel*), meaning "dependence, conditionality." For anyone accustomed to thinking in Buddhist terms, *ten* conveys the understanding that everything that exists is based on something already existing, namely, causes and conditions, whereas *drel* shows that nothing, not even the supporting factors, exists independently in its own right. Thus, a mere two syllables suffice to express the fact that there is no question of the *non-existence* of phenomena; phenomena do exist, but not in the way we have always believed they exist. Rather, they exist conditionally, being empty of any existence of their own. And just this is the famous emptiness (*stong-pa-nyid*, Skt. *śūnyatā*) that is one of the main points of the Buddhist teaching. A simple description of this way of seeing things scarcely gives any idea of how revolutionary its consequences are in actual experience. Nevertheless, I shall try to indicate some of the implications.

The loose structure of physical and non-physical factors that makes up our reality—including, of course, ourselves—is continually changing in all its aspects. These processes of change, and thus the organization of reality itself, can be influenced by us through our perceptions. We may assume that our present capacity for perception is limited and superficial, so that there is still plenty to be discovered. Since it has no inherent existence, reality will offer no resistance to this. Expanded perception will probably reveal to us a wider view of reality. Considerations of this sort lead to curiosity and openness; as a result, our usual self-imposed limitation of consciousness is, perhaps for the first time, slightly shaken.

If we carry on, we learn with constant practice to have a direct perception of reality. If that is, indeed, a worthwhile goal to aim at, then the question must be asked—how do we perceive things at present? The answer, which anyone can easily confirm, is this: Everything that presents itself to us in the way of impressions and perceptive stimuli, is at once, and prior to any other treatment, sorted into one of three possible categories—pleasant, unpleasant, or neutral. And the sole criterion for this allocation is the presumed effect the object may have on ourselves. Whatever confirms our ego is

pleasant; whatever threatens it or causes discomfort is unpleasant. Everything else is neutral. It is astonishing how many stimuli are instantly evaluated as pleasant or unpleasant. But of course we have had decades of practice in sorting things out. We take ourselves and our well-being—the focal point of all that happens around us—so seriously that for that reason alone we feel a compulsion to evaluate our impressions with speed and certainty.

In reality, of course, this simple sorting process involves a high percentage of error, but we have no difficulty in disguising this fact from ourselves for our entire lifetime. After the sorting, action follows automatically: we grab at the pleasant, and attempt to repel or destroy the unpleasant. The neutral is largely ignored. Owing to this procedure, objects gain an enormous power over us and our behavior. We are continually enslaved by them, and this bondage never comes to an end. We are constantly encountering pleasant objects, that we do not yet possess but greatly desire, and unpleasant objects, that threaten us. Total control is impossible, as we repeatedly and painfully rediscover. And so this entire frustrating process, in spite of being directed at our happiness and well-being, is in reality nothing but suffering. The tragedy is that we continually act like marionettes without understanding how and why. In fact, there is no hope for a change in our situation as long as this fundamental ignorance (*ma-rig-pa*) persists.

If we now return to the Buddhist statements about the emptiness of all phenomena, and apply them to ourselves, an astonishing realization begins to dawn: our own ego, too, for which we continually tremble, and which we at all costs want to be happy, is only a conditioned phenomenon with no independent existence of its own. It is exactly the same with all perceived phenomena. If that is the case, why do we madly sort them out? Why do we allow objects to have so much power over us? And indeed, we immediately put a stop to that madness the moment we overcome ignorance through gaining insight into emptiness. We still go on existing, and we maintain our capacity to rejoice in things of beauty and to feel pain from loss. But the feverish tension of hunting and being hunted has left us. We give up the urge to control and we learn to move without resistance in the stream of phenomena. Paradoxically, it is precisely through this attitude that our powers of influence grow and multiply. The exaggerated ego-fixation has held our energies in check. When that has gone, we feel better and can achieve more.

This insight into emptiness is thus regarded as the most powerful weapon against our fundamental ignorance and against all hindrances. It stops the process of erroneous perception, and the overloading of objects,

indeed of all reality, with a thick layer of concepts. It eliminates the artificial separation between "me" and "the rest of the world," thus ending our isolation. Understandably, insight into emptiness is therefore regarded as the instrument of immediate, instant, and final liberation from suffering.

Such considerations also answer the questions thrown up by a purely intellectual understanding of emptiness: "If our reality is actually devoid of self-existence, does it become barren, boring, and worthless? And, if I realize the emptiness of my ego, am I not then an automaton without feelings?" The answer is given, on the one hand, from what has been said above, namely, that the highest knowledge, the recognition of emptiness, abolishes ignorance—and with it, suffering (but not joy!). As for the understanding of reality itself, another answer emerges when we consider the other side of the coin: the *non-existence* of inherent existence is equal to the *existence* of an unlimited range of possibilities. All phenomena perceived by us, with their endless number of facets and forms, are merely a tiny segment—a momentarily experienceable expression—of a far greater possible reality with an indescribable range of expressions which can become manifest at any time in the form of dependent existence. Any change of even one of the above-mentioned influencing factors (components, processes, the perceiving subject, the process of perception) opens up new "channels of formation." Even just beginning an attempt at comprehending and evaluating these potentials in ourselves and in the phenomena around us fundamentally alters our life-situation in the direction of an improvement in quality.

What do we mean, in this context, by "quality"? In Tibetan, there is the concept of *chü* (*bcud*). *Chü* really means "essence-juice and vigor," or "contents." Originally, the word was probably used to describe the qualities of plants or food, but it is also used in a transferred sense for the pure "quality" of living beings, environments, energies, etc. The term "vessel-and-contents" (*snod bcud*), for instance, means the whole world. The idea that the universe consists of nothing but living beings and the environments they have created for themselves is—just as in the case of *tendrel*—briefly expressed in just two syllables.

Without attempting a definition in Western terms, I would like to give a few examples of the function or effect of *chü* as seen through Tibetan eyes.

We say, for example, that an intact and powerful landscape is endowed with *chü*. If we surrender ourselves to its power, we can draw *chü* from it for ourselves. Then we feel an influx of vitality, well-being, and clarity. (On the other hand, an atomic power station, with its particular field, may have plenty of energy—but little *chü*.) Charismatic people, or people in dramatic,

existential situations, radiate plenty of *chü*, but tired workers packed together in the evening commuter train have very little. A conversation that consists only of two hasty monologues that pass each other by is not marked by much *chü*, whereas genuine, profound communication based on sympathy and attentiveness is one of the most pregnant expressions of *chü* that can be found.

If there is a general lack of *chü*, people suffer very much without knowing exactly what is the matter with them. Perhaps they find their whole life somehow flat, colorless, and unsatisfying although outwardly everything seems to be fine. If their hunger for existential "quality" cannot in any way be satisfied, and when all substitute satisfactions fail, then psychological disturbances such as depression set in. So there is nothing more sensible we can do than to enrich our lives with "quality." This seems to me to be one of the points where it is necessary and desirable to create a bridge between Eastern and Western thought. For if we in the West have an ever greater need of *chü*, of genuine "quality" in our private and social life, we must be prepared to cast aside rigid, old, and limited concepts about ourselves and our reality. A new, expanded concept of reality depends, among other things, on the recognition and strengthening of *chü*, and on avoiding the destruction of existing *chü*. All that presupposes an increased power of perception and sensibility, which can only be gained by the application of spiritual methods. Intellectual activity is important, but preoccupation with philosophical thought-constructions alone does not help us forward here. Neither does the pious acceptance of religious precepts. Experience shows that mental training and meditation exercises directed towards gaining deeper knowledge make for the greatest progress in this direction. As a positive force or a pure "quality" in connection with phenomena, persons, and processes, *chü* is neither omnipresent nor a matter of course. It can be weakened or even virtually eliminated by a lack of sensibility. But it can also, through perception and respect, be cultivated and strengthened. In a culture which is primarily spiritually oriented, that is likely to be the case.

Let us now return to the question of "Tibet." It seems to be very generally agreed that the culture of Tibet, at least down to the end of the 1950s, embodied a high concentration of *chü*. Even if we are far from trying to idealize the historical Tibetan system, and even if, in general, every religious tradition has to be critically regarded with all its unavoidable weaknesses, it still remains a fact that practically all Tibetans had the subjective experience of *chü* as an integral part of their lives. According to their perception, pure "quality" was present—in their social system, in its principal representatives,

and, above all, in its religious foundations. However one may regard it—whether one considers the Tibetans as simple feudal slaves or as a nation with a highly developed spiritual culture—their subjective attitude was, in spite of all lack of sentimentality and their tendency to mock the weaknesses of their own system, totally and immovably shaped and penetrated down to the roots with *chü*. That is perhaps the reason why, even after decades of occupation and severe suppression, they still have the strength to hold fast to their national identity and their will to freedom with such determination that visitors to Tibet often remark on it, even to this day. But all that is by the way.

If, in one's own society, one shares the experience of *chü* with numerous other people in one's surroundings, near or far, a strong group identity develops, and a deeply rooted agreement on values held in common. The causes and results of *chü* extend by their very nature far beyond the bounds of everyday affairs. They are, as stated, a result of genuine spirituality, not artificial piety. I always try to see this complex in its total context and to present it accordingly. That is why I said at the beginning that the phenomenon of Tibet could not be explained by the word "religion" alone. For although religion or religious practice can certainly be filled with *chü*, it does not have to be.

Even among Tibetans, of course, only a few people understand—in this way—the connection between the Buddhist teaching, with its conception of reality determined by emptiness, and the perception and intensification of pure "quality" in all phenomena. Just as everywhere else, with us too there is a broad range of religious theory and practice, stretching from simple folk-belief up to the exercises and realizations connected with the most profound insight.

Non-Conventional Reality

Considerations of quality are equally important when we leave the level of our conventional reality. In various cultures and spiritual systems of doctrine, including that of Tibetan Buddhism, it is stated that the reality we can grasp with our senses is only one among many. We are convinced that it is possible to dissolve our current fixation on the conventional reality we know, to extend our consciousness far enough to be able to perceive other realities, and even to move among them with an identity of our own.

How do we set about learning this? In order to avoid overtaxing ourselves and becoming disoriented, we limit ourselves, in our tradition, at first to finding access to one alternative reality that is firmly defined and of

which precise descriptions exist. For this purpose, we need to work closely with someone who already possesses this access and can act as a teacher. Teacher and trainees make use of a common stock of descriptions and symbols that are connected with that alternative reality. At first, the trainees will only be able to understand and interpret the manifold ciphers and pieces of information supplied to them within the limits of their own conventional reality. But that does not matter. With a little support and continual effort, in time a different understanding develops, a direct and valid perception of non-conventional reality. The methods of achieving this are conveyed in Indo-Tibetan Buddhism under the heading of *tantra*.

Responding to the question of whether or not such a reality actually exists is not given primary emphasis. In any case, this point can only be finally settled by one's own experience. If there is no direct access, the most wonderful descriptions are of little use: whether you believe them or not is equally unsatisfactory. But if we fulfill the conditions and continue, with right motivation, to pursue the meditative practice, then—irrespective of whether in the beginning we can even imagine the existence of a different reality—we will inevitably activate ever subtler levels of our own consciousness, and thus learn to perceive differently. After a time, the tantric reality will be an unquestioned fact.

Let us assume that this hurdle has been overcome, and the existence of an alternative reality accepted. The question would still arise as to why we should trouble to explore other realities if we feel quite happy in our own inherited reality. A Buddhist would immediately consider that our conventional reality is narrow, limited, unsatisfying, and painful. In tantric reality, different rules apply which give the individual considerably more freedom. We have a chance, firstly through the very process of consciousness expansion and secondly through the enormous aid which contact with tantric reality brings, to make much greater progress on our own path. The path becomes, then, steeper and more perilous, more intense yet shorter. But above all, the fact remains that everyone must personally go every step of the way—there is no question of magic or vicarious redemption.

If we are attempting to cross the boundaries of conventional reality, we must naturally first find out how this can be done. The search for a bridge, for a common denominator between the two realities, leads us back to the theme of emptiness. The realization that the phenomena surrounding us lack inherent existence is a precondition for all further progress. As long as we imagine that things are, in their true nature, just the way they present themselves to our perception, we are trapped in a fine-meshed net.

WHAT ARE SYMBOLS, AND HOW DO THEY AFFECT US?

Now comes the question of what this virtually inexhaustible wealth of symbolic representations, filling innumerable colorful volumes on Tibet, has to do with a system of thought that is concerned with emptiness, dependent origination, and the introduction of tantric reality. I can think of no better example than that of holography. My physicist friends have explained to me that every single constituent part of a hologram contains the complete picture within itself. When I heard that, I had to think of our infinitely fine descriptions of mandalas (see p. 80). In these, every form, every object, every attribute, every gesture of a deity, as well as position and color and every point of the compass together with numbers, descriptions, series of movements and sounds, and so on, not only have their own particular significance, but are related to every other part of the mandala in such a way that, starting from any given element, I can build up, recognize, and interpret the whole. The same thing applies, in principle, to the groups of symbols I am concerned with in the present study. Let us consider an example. If I, as a Tibetan, come across the color white in any symbolic context, this at once releases a flood of associations: pictures of deities, white silk scarves (for ceremonial presentation), chalk drawings, vessels, substances like milk, yogurt, and white rice which are used in rituals—all with the signification of purity, peace, liberation, kindness, good fortune.

From a Tibetan point of view, symbols are signs which we use to remind ourselves of the interrelations between inward and outward, between mental activities and material appearances, so that we can recognize them more clearly. This awareness, in turn, enables us to influence reality—even in its future developments. Seen in this light, all elements of perception can be symbols, or *tendrel;* there is no essential difference between them and the common, generally employed symbols described in this book. The only difference is in conventional agreement. If many people belonging to a particular cultural group agree to regard a sign as symbolic of particular mental contents or forms of energy, then, for them, this symbol is effective, its effect being based on memory, trust, and the strengthening power of repetition.

What about the influencing of reality by the use of symbols? Here we might try, very cautiously, to distinguish between psychology and magic.

If we choose favorable days or particular places for particular things we want to do, of if we try to create a favorable atmosphere for our activities through prayers and the use of symbolic substances, then we undoubtedly gain encouragement and confidence, and our activities are positively influenced in a way that should not be underestimated. The result depends, to a

great degree, on our confidence, of which we can distinguish three types: a more or less emotional "confidence arising from a pure state of mind," a rather more convinced "confidence arising from belief," and a "confidence arising from aspiration."[2] Each one of these three types should be well founded, not based on blind faith, the teaching says. The extent to which these conditions are always fulfilled in actual practice is, however, another matter. As for the question of superstition which arises in this connection, I shall return to that later.

We have now reached the point where it is unavoidable to speak about the direct influencing of reality by magical means through the use of symbolic objects and substances. What do we mean by magic? Every reality, whether our conventional reality or, for example, tantric reality, is composed of its appearances (phenomena). This composition of phenomena follows a certain basic pattern, the dynamics and laws of which are not necessarily apparent on the surface or on the outside. In every higher culture there exists a deeper knowledge of these basic patterns. It is preserved and passed on by those who possess it. Whoever possesses a deeper knowledge of the powers, elements, lines, and influencing factors of which this reality is composed can influence it through this knowledge, but always within the framework of the laws of the pattern. Those who share this deeper knowledge within a common cultural frame of reference have, over the course of time, developed a symbolic language in which they can effortlessly make themselves understood and communicate. It is based on fixed linkages between external or material forms and mental contents. Such a symbolic language describes completely, and in a highly concentrated form, a "pool of knowledge" which has been formed over thousands of years.

In the use of symbols, such as for the purpose of influencing reality, this pool is drawn on. Those who have a sovereign command and a comprehensive understanding of this deeper knowledge and the symbolic language are naturally capable of drawing from the pool and releasing powerful effects. The members of this category as a rule feel closely drawn together. Actually, they do not even need to use a symbolic language any more, but they value it highly and carefully preserve it.

The considerably larger group of people who posses a partial knowledge are dependent on the concrete employment of the symbolic language in order, within the limits of their capacity, to siphon off something from the pool and to achieve some effects. What they lack in knowledge they can partly make up through trust and good motives.

By far the greatest number of people who would like to attempt "magic

rituals" (or what they believe to be such), possess virtually no deeper knowledge, and are dubiously motivated. However, if there is at least the desire to improve their motivation in the direction of selflessness, and to acquire the basis for dealing with reality in the course of a careful training over a number of years, it is possible for results to be achieved. Otherwise, such attempts will be at best useless, and at worst dangerous for their own mental health.

Any attempt—without knowledge and without well-founded confidence—to pick out individual elements from any system of symbolism for the purpose of showing off is something that we would regard as superstition, plain and simple. Different forms of superstition are found everywhere, including in Tibet. But what do we mean in this context by "well-founded" confidence? With the usual mixture of knowledge, presumption, belief, and imitation, it is hard to say in many cases where the boundary of superstition lies. It depends, of course, on the nature of the mixture. In general, we could perhaps say that, in order to guard against mere imitation and superstition, one must at least have made a thorough investigation oneself and discovered proof that a deeper knowledge in regard to symbols, practices, and rituals undoubtedly exists, even if one does not possess it oneself. Then it is possible to advance towards the acquisition of deeper knowledge. There are two extreme positions in regard to this difficult issue, neither of which is of much use. To want to rush blindly into experiments with reality the way one might try a new drug is harmful. On the other hand, to use the word "superstition" as a blanket designation for all magic, just because one knows nothing and wants to know nothing, although not actually dangerous, is rather senseless.

A further question remains to be clarified: How do these remarks about magic fit in with the Buddhist teachings about karma? Because of its introduction of magical means and methods, Tibetan Buddhism has often been called into question by representatives of other traditions. But I believe such doubts can be dispersed upon closer examination.

By "karma" we mean actions by means of which, through the law of cause and effect, we generate our own future experiences. Since it is a personal matter not extending beyond ourselves, our consciousness, and our behavior—without the intervention of any higher entity—the process of this law admits of no exceptions or "statutory limitations." So how does this fit in with the magical influencing of reality? In fact, it does fit without any contradiction because knowledge of the basic pattern of reality, on which all magic must be based, includes karma. It is a matter of a clear and unambiguous, but

not rigid and mechanical, understanding of karma. Using symbols and performing rituals does not mean indulging in some wild "magical conjuring"; rather, it involves working energetically yet sensitively with the given forces and conditions—extending the existing net with threads of the "possible."

As we shall see in our discussion of the individual groups of symbols, many objects or "lucky" substances seem to have been established as symbols or utilized for thousands of years. Most of them were used in the Indian religions, and in the course of centuries they have undergone various cultural assimilations and changes of meaning. As far as possible, I have attempted to follow these processes, basing myself principally on the Buddhist literature of Tibet, as it was received from India.

THE NINE BEST-KNOWN GROUPS
OF
SYMBOLS IN TIBETAN CULTURE

THE GROUPS OF SYMBOLS chosen for this study are those which are most frequently used in Tibet and Mongolia. They adorn religious buildings and private homes, they decorate furniture and other objects, and articles of clothing. They are thought to be recognizable in certain landscape formations, such as in mountain ranges. Innumerable forms of expression in public and private life are associated with them. The most favored group, by far, is that of the Eight Symbols of Good Fortune.

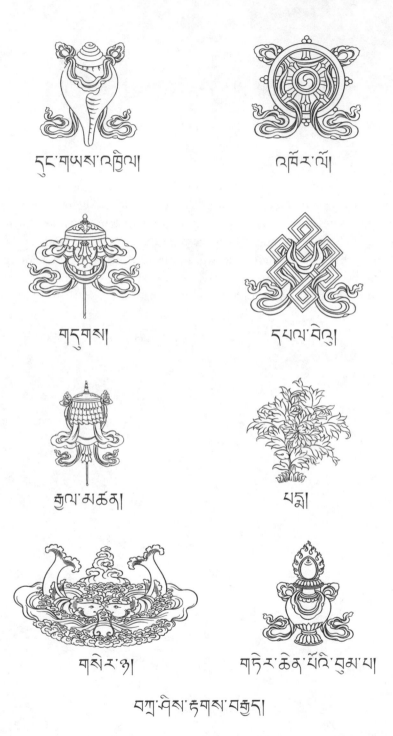

དུང་གཡས་འཁྱིལ།

འཁོར་ལོ།

གདུགས།

དཔལ་བེའུ།

རྒྱལ་མཚན།

པདྨ།

གསེར་ཉ།

གཏེར་ཆེན་པོའི་བུམ་པ།

བཀྲ་ཤིས་རྟགས་བརྒྱད།

1
THE EIGHT SYMBOLS OF GOOD FORTUNE
བཀྲ་ཤིས་རྟགས་བརྒྱད།

(bkra-shis rtags-brgyad, Skt. *aṣṭamaṅgala)*

FROM THE EARLY DAYS OF RELIGION in India, a number of auspicious signs and symbols have come down to us, the origin, age, and development of meaning of which can often scarcely be established. These are usually objects, animals, or plants which, because of their value or the manner of their employment, served as ritual objects, symbols of deities, or, generally, as status symbols. As they were always used in established ways, such as for daily worship or for ceremonies on particular occasions, it seemed natural to ascribe a special significance, transcending their individual importance, to these specific combinations. Such groups of symbols are found, with many variations, in Hinduism, Buddhism, and Jainism.[3] One such group (Fig. 1) consists of the Eight Symbols of Good Fortune, also called the Eight Auspicious Symbols. It is one of the most popular symbol groupings among the Tibetans, and also one of the oldest, being mentioned in the canonical texts,[4] which means that it goes back at least to the Sanskrit or Pali texts of Indian Buddhism. The following are the Eight Symbols of Good Fortune:

- the Parasol
- the Golden Fishes
- the Treasure Vase
- the Lotus
- the Right-Turning Conch Shell
- the Glorious Endless Knot
- the Victory Sign
- the Wheel

I will first describe the individual signs, and attempt, as far as possible, to explain their origin, meaning, and use. In describing them, I shall refer to the usual objects or representations, since the descriptions in the texts are in part symbolic, and not, in our sense, realistic. Often, too, the meanings

of the separate signs overlap, or at minimum, they are not clearly distin-
guished from one another (e.g., wheel/parasol, glorious knot/swastika, para-
sol/victory sign, seashell/conch shell, etc.). Thus, for instance, the first of
the Eight Symbols of Good Fortune, the parasol, is described as a construc-
tion with a thousand spokes.[5] I shall not indulge in any conjectures about
what this might mean and whether this statement is due to ritual exaggera-
tion. I shall confine myself to the description of parasols such as are actually
made in Tibet or depicted by artists, and which possess a perfectly normal
number of spokes.

THE PARASOL
གདུགས།
(*gdugs*, Skt. *chattra*)

THIS IS AN OPEN, single- to triple-parasol of honor, big enough for at least four or five people to stand under it. Yellow, white (according to the literature), or multicolored silk is stretched over wooden spokes. It is completed by a broad, folded silk valance. Each additional parasol is indicated by folded strips of silk, which are sewed to the lower edge of the parasol immediately above them. Eight single- or multicolored silk ribbons with fringes hang from the upper edge of the highest valance exactly down to the lower edge of the lowest one. The top is formed by a gilded pommel which may be of any shape or height. The staff is also of wood, sometimes gilded, but usually painted red.

The significance of a parasol as a symbol is not too mysterious. The ability to protect oneself against inclement weather has always, in all cultures, been a status symbol. In fact, even in Europe until a few decades ago, a sunshade was a status symbol for society ladies. A few thousand years ago in a country like India, anyone who owned such a luxury object was certainly one of the well-to-do. And if, in addition, one had servants who carried the parasol, then indeed one's rank and wealth were made very clearly manifest. Thus, the development of the meaning of the parasol as a symbol of power or of royal rank is easy to trace. Also, the fact that it protected the bearer from the heat of the sun was transferred into the religious sphere as a "protection against the heat of the defilements (*nyon-mongs*, Skt. *kleśa*)."

There may have been parasols in India of more than three stages. For example, we learn from the biography of Atiśa that he was entitled to thirteen parasols of honor.[6] In Tibetan art, these are represented in pictures and on painted scrolls (*thang-ga*) as being piled up one on top of the other.[7]

The Tibetans took over the parasol from Indian art. High religious dig-
nitaries were entitled to a silk parasol, and secular rulers to one embroidered
with peacocks' feathers. If some personality in public life, such as the Dalai
Lama, was entitled to both, first a peacock feather parasol was carried after
him in the procession, and then a silk parasol, each with one or three
valances. But the number of valances was not taken to symbolize more than
one parasol; it was just a matter of personal taste. In Tibet, there never
seems to have been a large number of parasols heaped one above the other
as there was in India. Practical considerations kept this down to the usual,
portable form.

Within the Eight Symbols, the parasol stands as a sign of spiritual
power in a positive sense; as with many other signs (e.g., the Seven Jewels of
Royal Power, p. 65), the meaning of the symbol is transferred from the
worldly to the spiritual level.

THE GOLDEN FISHES

གསེར་ཉ།

(gser-nya, Skt. suvarṇamatsya)

THIS SYMBOL CONSISTS OF TWO FISHES, which usually appear standing vertically and parallel, or slightly crossed, with heads down and turned towards each other. Originally, in India, the fishes represented the sacred rivers Ganges and Yamuna.[8] As early as the second or third century C.E., they were put on clay vessels.[9] As symbols of good fortune they found their way into the traditions of Jainism[10] and Buddhism. In Tibet, they are only found in pictorial representations in connection with the Eight Symbols. The Tibetans did not give them any special meaning of their own.

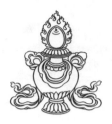

THE TREASURE VASE

གཏེར་ཆེན་པོའི་བུམ་པ།

(gter-chen-po'i bum-pa, Skt. *kalaśa)*

THE VASE IS A FAT-BELLIED VESSEL with a short, slim neck. The upper opening is formed by a kind of turned-down, fairly broad rim with decorations. The base is a round stand, also decorated. On top, at the opening, there is a large jewel which indicates that it is a treasure vase.

As regards the general meaning of vases and similar vessels, it can be said that their cult employment goes back to the early days of religion. Their symbolic meaning was probably always associated with ideas of storage and the satisfaction of material desires. In the sagas and fairytales of many different cultures, for example, we find the recurring idea of the inexhaustible vessel. At a spiritual level, the vase is often associated with the possession of supernormal abilities.[11] In Tibetan Buddhism, there are various different forms of vases for different purposes, especially for tantric rituals.

The special form of the treasure vase seen among the Eight Symbols is a sign of the fulfillment of spiritual and material wishes, and is also an attribute of particular deities who are connected with wealth, such as Kangwa Sangpo (*Gang-ba-bzang-po*),[12] one of the companions of Vaiśravaṇa.

THE LOTUS
པདྨ།

(padma, Skt. *padma)*

THE LOTUS DOES NOT GROW IN TIBET, and so Tibetan art has only stylized versions of it. The difference can easily be seen by comparing these with Indian or Japanese representations. Also, Tibetan lotuses, as we know them from painted scrolls and statues, show a considerable range of variation. In the Eight Symbols, the basic form is employed—a white flower with slight reddish shading, with or without a stem.

The lotus is altogether one of the best-known symbols. It is considered to be a symbol of purity, or of pure or divine origination,[13] for, although it has its roots in the mud of ponds and lakes, it raises its flower in immaculate beauty above the surface of the water. It is true that there are other waterplants that bloom above the water, but only the lotus, owing to the strength of its stem, regularly rises eight to twelve inches above the surface. Within the group of Eight Symbols also, the lotus stands for purity, especially mental purity.

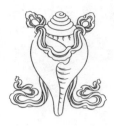

THE RIGHT-TURNING CONCH SHELL
དུང་གཡས་འཁྱིལ།
(dung g.yas-'khyil, Skt. dakṣiṇāvartaśaṅkha)

THE CONCH IS WHITE, fairly big, spiral, and oval with pointed ends. The right-turning (clockwise-spiraling) form is considerably rarer than the left-turning form, and is therefore considered more valuable. As a natural object, not made with human hands, it is one of the oldest ritual objects. It is often referred to as a seashell and sometimes as a snail shell. The Tibetan term *dung* covers both.

In pre-Buddhist times, it already served as an attribute or symbol of Hindu gods, as a symbol of femininity, or, more generally, as a cult vessel or instrument.[14] When adopted into Tibetan Buddhism, it was particularly valued for its powerful sound as an instrument. Shells or conches are used both to call together the assembly and during the ritual as a music offering, or as a container for the saffron water. They also serve as ornaments for decorating thrones, reliquaries (*chos-rten,*, Skt. *stupa*), statues, and so on.

Among the Eight Symbols, it stands for the fame of the Buddha's teaching, which spreads in all directions like the sound of the conch trumpet.[15] It thus has a purely religious significance.

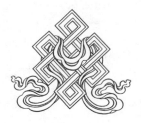

THE GLORIOUS [ENDLESS] KNOT
ད་པལ་བེའུ།

(dpal be'u, Skt. *śrīvatsa)*

THE ENDLESS KNOT IS A CLOSED, graphic ornament composed of right-angled, intertwined lines. It is often associated with the Hindu *śrīvatsa* sign. In its earliest form, this seems to have been a *nāga* symbol[16] with two stylized snakes.[17] Subsequently, a graphic symbol developed out of it which is described as representing a curl of hair, or else a blossom with four or eight petals. Just how the endless knot of the Tibetans is supposed to have developed out of this is not quite clear to me. I could more easily imagine a connection with the *nandyāvarta* symbol,[18] a variant form of the swastika, which, at least in its execution, bears some resemblance to the endless knot. As regards its role in Tibetan Buddhism, there are no surviving reminiscences of possible earlier meanings, and there are no textual references to it. For the Tibetans, the endless knot is the classic sign for *tendrel,* the way in which reality exists. The intertwining of the lines reminds us of how all phenomena are intertwined and dependent on causes and conditions. The whole is comprised of a pattern closed in on itself with no gaps, which at once expresses motion and rest, all in a representational form of great simplicity and fully balanced harmony. It is thus understandable that the endless knot is one of the favorite symbols in Tibetan culture. Used not only in connection with the Eight Symbols, it also appears quite frequently on its own. It reminds the viewer of *tendrel,* and is at the same time the simplest, clearest, and most concise expression of *tendrel.* It is therefore conceived as being auspicious in the highest degree. The mode of operation of this symbol is always experienced at many levels. Since all phenomena are interrelated, the placing of the endless knot on a gift or on a greeting card is understood to establish an auspicious connection between the giver and the recipient. At the same time, the

recipient is supposed to be linked up with favorable circumstances in the future, being reminded that future positive effects have their roots in the causes of the present.

Since the knot has no beginning and no end, it also symbolizes the infinite knowledge of the Buddha.

THE VICTORY SIGN
རྒྱལ་མཚན།
(rgyal-mtshan, Skt. *dhvaja)*

THE CONCEPTS OF "victory sign," "banner," and "flag" correspond to various objects in Tibetan culture which stand in some kind of relation to each other either on account of their form or their name. In Table 1 (p. 29), I have listed these various designations in survey form, including, for the sake of completeness, the parasol. In this context, I employ normal Tibetan linguistic usage for these, unless otherwise stated. The victory sign *(rgyal-mtshan)* is the sign that belongs to the Eight Symbols. Just like the parasol, it is made out of wood and cloth, or imitated in metal. A glance at Table 1 shows that the victory sign is not described anywhere in classical Tibetan literature.

At this point, I would like to mention a particular form of this sign which I believe developed in Tibet from the various types of parasol described above. It consists of a narrow cylinder of cloth with at least three rows, but generally several more, of folded silk valances of uneven number. The cloth is stretched over a wooden frame, and crowned with a pommel which is often adorned with four silk ribbons. This object, often imitated in metal, is found in and around monasteries or temples, and is popularly referred to as "victory sign." However, one of these victory signs, which is suspended from the ceiling as a decoration, exactly in the middle of the main assembly hall of a monastery, is called by the monks the "yellow central parasol" *(dkyil-gdugs-ser-po).* This designation, and the fact that such an object is nowhere described in the texts, leads me to conclude that it is probably a stylized form of multiple-banked parasols of honor.

In this way, we could explain how this object developed as a special form of parasol. But how the designation "victory sign," adopted from the classical literature, came to be applied to just this particular object can no

longer be decided. It is a fact, however, that together with the name, the symbolic meaning also was conveyed to the object, i.e., "sign of victory over all disagreements, disharmonies, or hindrances" (*mi-mthun phyogs-las rgyal-ba'i rgyal-mtshan*).[19] Thus, as is so often the case, the symbolic meaning was transferred from the worldly to the religious level.

For the Tibetans, therefore, the sign of victory symbolizes primarily the victory of the Buddhist teaching, the victory of knowledge over ignorance or the victory over all hindrances, the attainment of happiness. At the same time, it incorporates the wish to bring about permanent, enduring happiness—both of the transient, worldly kind and of the ultimate kind—in the sense of *tendrel.*

This sign is also seen apart from the Eight Symbols, for instance, for the adornment of temple roofs. The roofs of private houses in which there was a complete set of the canonical texts, the *Kangyur* (*bKa'-'gyur*), were also allowed to be so adorned. The victory sign can serve as a hanging ornament in temples, as the finial of both the long prayer-flag masts (*dar-chen*) and the flagstaffs for the Tibetan national flag, and as an attribute of certain deities, such as Vaiśravaṇa, the guardian of wealth.[20]

Object	Parasol, round, one to three valances	Victory sign, cylindrical, three or more valances of uneven number	Banner, flat, curved form, three pairs of animals superimposed	Banner, flat, curved form, without animals superimposed	Flag, flat, straight form
Sketch					
Tibetan term in common usage	gdugs	rgyal-mtshan	ba-dan	ba-dan	phan
Special form in monastic language	—	dkyil-gdugs-ser-po	—	—	—
Tibetan term in classical literature	gdugs	—	rgyal-mtshan	ba-dan	phan
Sanskrit name	chattra	(dhvaja, taken from classical literature as term for rgyal-mtshan)	dhvaja	pataka	patta

Table 1

THE WHEEL
འཁོར་ལོ།
('khor-lo, Skt. cakra)

THE WHEEL, AS ANOTHER graphic symbol among the Eight Symbols, consists of hub, rim, and generally eight spokes, sometimes more. The circle as its underlying form is a universal symbol found in all cultures. In pre-Buddhist India it mainly had two meanings, firstly as a weapon, and secondly as a symbol for the sun, or, derived from this, for time or for any kind of cyclical motion.[21] The number of spokes varied according to tradition—six, eight, twelve, thirty-two, or one thousand. These were often equated with the points of the compass or with a centrifugal motion, while the rim represented the element of limitation. The hub was interpreted as the axis of the world. The wheel was used as an emblem or attribute of Hindu deities.

The weapon symbolism of the wheel entered Buddhism in the form of the protective wheel which is part of the meditative visualizations of particular tantric rituals.[22] This protective wheel is represented without a rim. This may point to its having developed simply from the motion of a weapon swung in a circle.

However, the most important, and best-known form, and the form that belongs to the Eight Symbols, is the wheel of Dharma which the Buddha set in motion with his first discourse. Accordingly, in Buddhism, there are various explanations of its significance. One of these explanations makes reference to the three trainings[23] of Buddhist practice: the hub stands for the training in moral discipline, through which the mind is supported and stabilized; the spokes stand for the application of wisdom in regard to emptiness, with which ignorance is cut off (here again a hint of the "weapon" aspect); the rim denotes the training in concentration, which holds the practice together.[24]

Within the Eight Symbols of Good Fortune, too, the wheel has a purely religious meaning as symbolizing the Buddhist teaching. It reminds us that the Dharma is all-embracing and complete in itself. It has no beginning and no end, and is at once in motion and at rest. Thus, the Buddhists see it as expressing the completeness and perfection of the teaching, and the wish for its further dissemination.

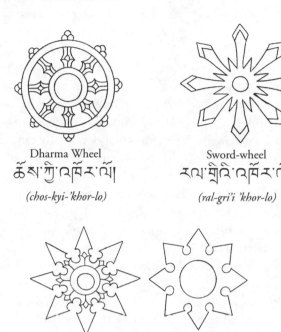

Dharma Wheel

ཆོས་ཀྱི་འཁོར་ལོ།

(chos-kyi-'khor-lo)

Sword-wheel

རལ་གྲིའི་འཁོར་ལོ།

(ral-gri'i 'khor-lo)

Wrathful Weapon-wheel

དྲག་པོའི་མཚོན་ཆ་འཁོར་ལོ།

(drag-po'i mtshon-cha 'khor-lo)

Wrathful Weapon-wheel with Eighteen Spokes

རྩེ་མོ་བཅོ་བརྒྱད་པའི་དྲག་པོའི་མཚོན་ཆ་འཁོར་ལོ།

(rtse-mo bco-brgyad-pa'i drag-po'i mtshon-cha 'khor-lo)

GENERAL MEANING OF THE EIGHT SYMBOLS OF GOOD FORTUNE

We have now given the explanations of the individual signs. It remains to inquire why these particular eight signs were chosen to form a group. In the canonical texts, there are some passages in which the body, speech, and mind of the Buddha are compared to the Eight Symbols of Good Fortune. *The Heap of Good Fortune Sutra* (*'Phags-pa bkra-shis brtsegs-pa zhes-bya-ba theg-pa chen-po'i mdo*, Skt. *Āryamaṅgalakūṭanāma-mahāyānasūtra*) contains the following:

> Veneration to you with your head like a protecting parasol
> of good fortune,
> With eyes like the precious golden fishes of good fortune,
> With a neck like a precious, adorned vase of good fortune,
> With a tongue like an open lotus leaf of good fortune,
> With speech like a right-turning Dharma shell of good
> fortune,
> With a mind like a radiant, glorious knot of good fortune,
> With hands like precious, excellent jewels of good fortune,
> With a body like a precious, imperishable victory sign of
> good fortune,
> With feet that possess the wheel of good fortune of enlightened
> activity,
> The eight auspicious things are the best of excellent realizations.
> May every good fortune of these eight precious things
> Allow good fortune to rain down on us here and now.
> May there ever be well-being through these signs.[25]

Certainly, corresponding comparisons could have been found for any other combination of symbols of good fortune. In the *dGa'-ldan dar-rgyas gling-gi chos-spyod-las mnga'-'bul-skor bzhugs-so*, the Eight Symbols of Good Fortune are also described as qualities of the Buddha, but with more detailed and slightly varied comparisons:

> On the parasol:
>> From the head of the victor comes a cool, excellent shade which protects [us]. He is [like] an object that is well supported through the hundred powers of the threefold confidence of the beings to be tamed. He is quite surrounded

by the folds of compassion. May blessings radiate from the parasol of good fortune.

On the golden fishes:
They arise out of the sea of the eyes of the omniscient one, and move in the water of benefit for others, which consists of the combination of method and wisdom. Their golden eyes are the two kinds of beneficence. The sweep of the fins of their activities is great. May blessings radiate from the golden fishes.

On the treasure vase:
From the neck of the omniscient one [streams] the inexhaustible heavenly treasure. The realm of desire is represented by the rim, the realm of form by the belly and its contents, the formless [realm] by the hollow space. The decorations [correspond to] the glory of samsara and nirvana. May blessings radiate from the vase of good fortune.

On the lotus:
Out of the tongue of the man-lion (i.e., the Buddha), an immaculate object comes to be. Although he protects his companions in the swamp [of samsara], he is unsullied and of a beautiful color. The fortunate bees enjoy the perfume of perfect liberation. May blessings radiate from the lotus of good fortune.

On the right-turning conch shell:
From the teeth of the best guide, an immaculate, self-made object (i.e., not made by human hands) comes to be. The lines run round to the right like a perfectly pure staircase. Whatever comes into contact with the Dharma sound of the Great Vehicle (*theg-pa chen-po*, Skt. *mahāyāna*) is linked to the wholesome. May blessings radiate from the conch shell of good fortune.

On the glorious knot:
The secret spirit of all victory is symbolized in this vessel. The swastika contains the net of continuity. It is the

outstanding jewel of the essence of the inexhaustible treasure. May blessings radiate from the glorious knot of good fortune.

On the sign of victory:
> The splendid body of the victor becomes the object of complete victory in all directions. His precious top ornament liberates from all existences. The various folds of silk signify his not resting in peace (i.e., nirvana). May blessings radiate from the victory sign of good fortune.

On the wheel:
> It came to be well fashioned from the clear, genuine, pure gold of the two collections [of merit and wisdom]. It has the thousand spokes of the innumerable enlightened activities. It is the great source of the four groups [of what can be wished for], namely: Dharma, wealth, love, and liberation.[26] May blessings radiate from the wheel of good fortune."[27]

Texts like this consist of practically nothing but a series of coded statements, rather like a computer program. When the program is running, it produces numerous effects which cannot be seen, especially by the non-expert, from the written code. Almost every word can be explained from at least three levels of meaning, which a literal translation simply cannot bring out. A commentary can help us a bit further, but the sum total of the possible and intended associations can scarcely be communicated to those who do not have the appropriate background of experience.

Nevertheless, I shall try to illustrate, from the seventh strophe of this text, some of the many meanings that can be extracted from the various phrases. The strophe reads:

> The splendid body of the victor becomes the object of complete victory in all directions. His precious top ornament liberates from all existences. The various folds of silk signify his not resting in peace (i.e., nirvana). May blessings radiate from the victory sign of good fortune.

The various terms and expressions produce, for instance, the following

associations. By "victory" we understand the overcoming of all obstructions (*sgrib-pa*, Skt. *āvaraṇa*), illusions, and mental hindrances, i.e., the state of buddhahood. A buddha, a "victor," then, has "completely" and finally realized this state, indeed "in all directions," i.e., in every respect, in every way, without limitations. The achievement of buddhahood is the same as the attainment of the two enlightened bodies, the Truth Body and the Form Body, by which, in the widest sense, we can understand the perfect wisdom and the perfect activities, respectively, of a buddha (see pp. 44–46). These two aspects combine to form the "splendid body" of an enlightened being as a symbol of the state of buddhahood.

The enlightened body of a buddha, again, is symbolized by the "object" of complete victory in all directions, i.e., the sign of victory. Its "precious top ornament," i.e. the highest point and crowning conclusion, likewise symbolizes buddhahood as the highest state and complete liberation from samsara, the cycle of compulsory rebirths. The "various folds of silk" denote the manifold activities of a buddha.

The development of perfect activities presupposes freedom from all hindrances. One possible hindrance to the attainment of buddhahood, and such enlightened activities, is "resting in the peace of nirvana," that is, in a state of individual liberation. If one wants to conquer this hindrance on the way to buddhahood, it is necessary to wrest oneself firmly away from the peace of nirvana. All this is made clear by the silk folds of the victory sign.

But the Tibetan expression "not resting in peace" (*zhi-la mi-gnas*) also suggests another meaning. Those who do not rest in peace, who in fact find themselves in the usual peaceless state of ordinary human beings, are meant to be reminded, by the folds of silk representing the activities of a buddha, of the possibility of spiritual development and the conquest of suffering, and thus to be positively influenced, in "various" ways, since human beings are remarkably varied in their nature and capacities.

The "silk"—an especially noble, fine, soft, and supple material—symbolizes the skilled methods of the Buddha, who turns to all living beings and is able effortlessly to adapt himself to all situations, circumstances, and possibilities. The brilliance of his activities draws people to him, just as one can scarcely refrain from touching a piece of silken material, when such is encountered.

The above is a brief description of the images and thoughts that arise in the mind of a correspondingly educated Tibetan when such texts are recited. These few indications are far from complete. If we had unlimited space and time at our disposal, we could deal with practically every word of every text in

similar fashion. We keep on returning to the "holographic principle" described in the introduction, according to which the whole is contained in each element, from which observations and interpretations can be made. Every symbol leads, on closer inspection, toward an understanding of the totality.

In any case, even a superficial analysis has shown that the employment of the Eight Symbols of Good Fortune expresses the intense wish to present favorable conditions on both the worldly and the religious planes, and to bring them about in their totality. In addition, the number eight has a special significance in the context of the Buddhist tradition.[28]

HOW THE EIGHT SYMBOLS OF GOOD FORTUNE ARE USED

Pictorial representations of the Eight Symbols of Good Fortune are found, among other places, on ritual objects, miniature cult pictures (*tsak-li*), and painted scrolls. They are applied as decorations to walls and beams, on the sides of thrones, and on various objects of religious and everyday use. They are drawn in white or colored powder along the way to be traversed by high spiritual or secular dignitaries. They are further used as physical or mentally imagined offerings on various occasions.

There is thus a tantric ritual called "perfect dwelling" (*rab-gnas*) for the purpose of inducing a blessing (*byin-rlabs*), which is performed at the making, filling, and consecrating of statues, at the consecration of buildings, or during the blessing of fields. The lama calls on the "wisdom beings" (*ye-shes-pa*, Skt. *jñānasattva*), gives them offerings in the form of the Eight Symbols, and blends them with the object to be blessed. This appeal and "blending" is the core of almost all tantric rituals. The Tibetan interpretation of this process is that the master performing the ceremony is in continual contact with tantric reality. Owing to his meditative skills, he can draw a special spiritual energy from all directions, concentrate it, and bring it into a lasting union with an imagined or real object. The "summoned" energies are referred to as "wisdom beings," and the physical or imagined objects of the blessing are called "representational beings" (*dam-tshig-pa*, Skt. *samayasattva*).

There are various texts for this ritual. One of the most extensive is that used by the Upper Tantric College (*rGyud-stod grva-tshang*). The presentation of the offerings is accompanied by the following recitation:

> Just as previously the white parasol with the golden staff was offered to the Buddha, so also will I offer it. May it please you to accept it.

Just as previously clothes with the picture of the golden fishes was offered to the Buddha, so also will I offer it. May it please you to accept it.

Just as previously the good vase which fulfills all hopes was offered to the Buddha, so also will I offer it.

Just as previously the white lotus, unsullied by the filth of the swamp, was offered to the Buddha, so also will I offer it.

Just as previously the right-turning conch shell, resounding in the ten directions with the fame of the Dharma, was offered to the Buddha, so also will I offer it.

Just as previously the glorious (endless) knot, which turns like a swastika, was possessed by the Buddha for the sake of virtues, so also will I offer it.

Just as previously the victorious banner of Dharma, which conquers the hindering demons of the defilements, was offered to the Buddha, so also will I offer it.

Just as previously the golden-rimmed wheel was offered to the Buddha by the great Brahma, so also will I offer it.[29]

Another ritual in which the Eight Symbols are used as offerings is the ceremony for "firmly remaining" (*brtan-bzhugs*). In essence, it is a request to the lama to remain for a long time in his or her present incarnation. Here is the accompanying recitation as found in one text:

I offer the wheel, the victory sign, the parasol and the glorious knot, the lotus, the treasure vase, the golden fishes and the right-turning conch shell—the eight signs that best represent good fortune. By this, may good and wholesome effects spread in all directions and throughout all time.[30]

If, in the course of a tantric initiation, the disciples receive authorization (*dbang*) as vajra teachers, then their own teacher presents them with the Eight Symbols of Good Fortune as an offering.[31] The designation "vajra

teacher" (*rdo-rje slob-dpon*) is generally used for a teacher of tantra. The vajra (*rdo-rje*, "lord of stones") is one of the most important individual symbols in all of Tibetan Buddhism. It represents the indestructibility and imperturbability that characterize the highest level of mind, such as is aimed at in tantra. And the tantric methods are regarded as the most powerful when it comes to overcoming the mental poisons. The tantric master is accordingly termed "holder of the vajra" (*rdo-rje 'chang*, Skt. *vajradhara*). That means that he is in full possession of the power to use these methods. He regards it as his task to pass the vajra on to his disciples. Appropriate chants, then, are part of the consecration ceremony. Thus, in this context, "handing over the vajra" does not mean merely that the disciple is handed the ritual object called vajra, made of metal and generally having five spokes. Rather, it is in this symbolic action that the vajra master, during the mutual meditations of the initiation ceremony, directly passes on his power to the disciple, so that the latter becomes a potential vajra teacher, and therefore worthy to receive offerings.

At the enthronement of a person of high spiritual or worldly rank, too, the Eight Symbols are used as offerings. This is seen in the autobiography of Trijang Rinpoche (*Khri-byang Rin-po-che*) wherein he describes the enthronement of Takdrak Rinpoche (*sTag-brag Rin-po-che*) as Regent of Tibet—and representative of the still minor Fourteenth Dalai Lama—in the Iron-Snake Year (1941), and likewise the symbolic re-enthronement of the Fourteenth Dalai Lama himself on his flight from the Chinese in 1959, just before crossing the Tibet-India frontier. In both cases, Trijang Rinpoche mentions the presentation of the Eight Symbols of Good Fortune.[32]

They can also be used in rituals marking the New Year, in ceremonies of gratitude, and quite generally in all rituals by which planned activities (e.g., journeys) are to be favorably influenced.

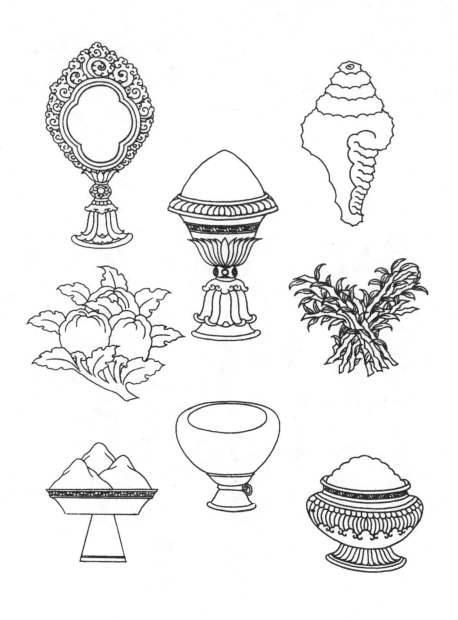

བཀྲ་ཤིས་རྫས་བརྒྱད།

2

THE EIGHT BRINGERS OF GOOD FORTUNE

བཀྲ་ཤིས་རྫས་བརྒྱད།

(bkra-sis rdzas-brgyad, Skt. *aṣṭamaṅgaladravya)*

THE COLLECTION OF SYMBOLS known as the Eight Bringers of Good Fortune consists of the following objects:

- the Mirror
- the Ghiwang Medicine
- the Yogurt
- the *Dūrvā* Grass
- the *Bilva* Fruit
- the Right-Turning Conch Shell
- the Cinnabar
- the Mustard Seeds

The Eight Bringers of Good Fortune, like the Eight Symbols of Good Fortune, are mentioned in the canonical texts.[33] They are also mentioned in many Tibetan texts, for instance in the *List of Terms that Occur in the "Basket" which Contains the Knowledge of Tantra (gSang-ngags rig-pa 'dzin-pa'i sde-snod-las byung-ba'i ming-gi grangs)* by Longdol Lama *(kLong-rdol bLa-ma)*.[34]

There are various explanations of their symbolic meaning, which differ considerably in points of detail and emphasis. Because of its comprehensive and profound explanations, *An Explanation of Auspicious Substances and Symbols (bKra-shis rdzas-rtags-kyi bshad-pa khag-cig)*[35] by the Sixth Paṇchen Rinpoche, Losang Thupten Chökyi Nyima *(bLo-bzang-thub-bstan-chos-kyi-nyi-ma,* 1883–1937), has been drawn on here. I have translated extracts from the text and supplied a partial commentary, in order to illustrate the understanding of the symbols from a Tibetan Buddhist point of view.

As regards the general importance of his *Explanation*, it should be noted that the Paṇchen Rinpoche always links the signs with explanations from the fields of either tantra or the bodhisattva path. As already mentioned in the preface, such a procedure serves always to embrace the various elements of the outer, visible world and the inner, meditative world as *tendrel*, and to

link them together.

Thus, for example, with every symbol he refers to the concept of "benefit" (*don*), which in the case of the mirror is "the perfection of benefit for oneself" (*rang-don phun-tshogs*), while for the other signs it is "the perfection of benefit for others" (*gzhan-don phun-tshogs*). Therein are contained the two thoughts which together comprise a unity, and form the motivation of the Great Vehicle. This motivation is, on the one hand, the wish to attain buddhahood, i.e., to seek one's own benefit, and, on the other hand, the wish to be able to help all beings in the best possible way, i.e., to seek the benefit of others. In the "mind of enlightenment" (*byang-chub-kyi sems*, Skt. *bodhicitta*) these two forms of benefit coincide to form a single entity of mind: the wish to attain buddhahood is nothing other than the wish to be able to help all beings in the best possible way—and vice versa.

The seven signs that are connected with the perfection of benefit for others can also be assigned to the four kinds of enlightened activity[36] as follows:

1. Peaceful activities: *ghiwang* medicine
2. Activities of increase: yogurt, *dūrvā* grass, *bilva* fruit, conch shell
3. Activities of power: cinnabar
4. Activities of wrath: mustard seeds

In discussing the sign of the *ghiwang* medicine, *An Explanation of Auspicious Substances and Symbols* expressly mentions that the four kinds of enlightened activities are a distinctive feature of tantra and, further, that they are connected with the Eight Bringers of Good Fortune (see p. 48).

Appearing in the text also are occasional references to the bodies of an enlightened being and to the five buddha families (*rgyal-ba rigs-lnga*, Skt. *pañca jina*). The Panchen Rinpoche's explanations are therefore probably directed at a readership that is familiar with the more advanced studies and forms of practice. The term "bodies of an enlightened being" will be explained in our discussion on the sign of the mirror. The meaning of "the five buddha families" is briefly set forth below.

The methods of tantric practice require the practitioner to work intensively with his or her individual reality, which is composed of the five aggregates:[37] form, feeling (sensation), perception, karmic formations, and consciousness. These five aggregates, or in Sanskrit, *skandhas*, are the basis of our self-identification, the basis of our sense of ego. At the same time, they are the starting point—and the sum total of our "working material"—

in our striving to attain buddhahood. At the beginning of our spiritual journey, we possess nothing but these five *skandhas* in their unpurified form. Obstructions, illusions, and ignorance hinder us in making use—except in a very limited, imperfect, and painful manner—of the possibilities that are present as predispositions in the components of our personality.

In like manner, the mind is also polluted by the five poisons of hatred (*zhe-sdang*), ignorance (*gti-mug*), arrogance (*nga-rgyal*), miserliness (*ser-sna*), attachment (*'dod-chags*), and envy (*phrag-dog*), which, in course of time, are transformed by meditation practice into the five wisdoms (*ye-shes lnga*) of a buddha. In parallel with this, the five *skandhas* are transformed into their perfectly purified aspects as the bodies of the five primordial buddhas: Akṣobhya (*Mi-bskyod-pa*), Vairocana (*rNam-par-snang-mdzad*), Ratnasambhava (*Rin-chen-'byung-ldan*), Amitābha (*'Od-dpag-med*), and Amoghasiddhi (*Don-yod-grub-pa*). They are regarded as the five aspects of buddhahood.

On this basis, the practitioner can utilize all the elements that constitute his or her world for spiritual transformation since the five primordial buddhas are each correlated, in a definite order or sphere (*dkyil-'khor*, Skt. *maṇḍala*), to colors, points of the compass, elements, emblems, and modes of wisdom, which also stand in opposition to the respective *skandhas* and false attitudes, and yet correspond to them.

Every one of the innumerable tantric meditational deities, although "embracing" all five aspects, centers on one principal aspect, thus emphasizing particular qualities and tendencies, which, in turn, form the basis for the essential points of each one's practice. Explanations of this are given in *dPal gsang-ba 'dus-pa mi-bskyod rdo-rje'i dkyil-'khor-gyi cho-ga dbang-gi don-gyi de-nyid rab-tu gsal-ba*, a text by Tsongkhapa (*Tsong-kha-pa*).[38]

In any case, the individual reality of a practitioner who has reached the goal—the attainment of buddhahood—is still composed of the five *skandhas*, but these are now in transformed, perfectly purified forms called the five buddhas or the five buddha families.

THE MIRROR
མེ་ལོང་།

(me-long, Skt. ādarśa)

ALTHOUGH IT IS NOT a natural product, but man-made, the mirror lends itself especially well as a symbol: it is bright and shining, and it impartially reflects all objects. In this way, it is a suitable image for certain functions of the human mind. The mirror is used not only in connection with the Eight Bringers of Good Fortune, but also, on its own, in rituals such as the "washing ceremony" (*khrus-gsol*).[39]

An Explanation of Auspicious Substances and Symbols explains:

> The mirror is a sign (*rten-'brel*) of the perfection of benefit for oneself…The mirror has two qualities: it is free from rust (*g.ya'-dag-pa*), and it reflects various forms. In this manner, the subtle consciousness (*sems-nyid*), which by its own nature is clear and perfectly free from adventitious stains (*glo-bur-gyi dri-ma*), [gives rise to]:
> - the Nature Body, i.e., the perfect abandonment [of all negative factors] (*spangs-pa phun-tshogs*); this body possesses two purities…;
> - the Wisdom Truth Body, i.e., the perfect attainment [of all positive factors] (*rtogs-pa phun-tshogs*), which simultaneously and directly embraces all forms, whatever they are and however many they may be (*ji-lta ji-snyed*).
> It was in order to gain these two bodies that the mirror, which as a sign possesses to perfection all the conditions for this, was once offered to the Buddha Śākyamuni…[40]

That is what the text says. What are we to understand by it? Full interpretation of all the symbols are not possible within the limits of this study, but I shall use the example of the mirror to give a few further hints so as to facilitate the understanding of these explanations from the Tibetan Buddhist point of view.

The mirror is described as "clear" and "perceiving." It therefore possesses two of the three characteristics of consciousness (unlimited, clear, perceiving), and accordingly becomes a symbol of this. We distinguish between a main consciousness (*gtso-sems*) and a series of conditioning factors or transient "ebullitions" (*sems-byung*), which can alternately manifest in relation to this consciousness. The best-known list mentions fifty-one such "mental factors." All of us are aware of our surface consciousness, with which we move in daily life, and which directs our actions. But beneath the surface consciousness there are progressively more subtle layers, down to the subtlest consciousness (*gnyug-sems*), which stores up impressions of every relevant action of the individual. Rebirth is based on this storage function of the subtlest consciousness, which is the common denominator between successive existences. The previously stored-up impressions are at some time—in the same or a subsequent existence—called up or activated as experiences. This is only comprehensible on the basis of a worldview in which a perceiving, interpreting, and shaping relationship exists between the individual's consciousness and his or her reality.

The layers below surface consciousness are normally inaccessible to human intervention. However, for the practitioner, they become gradually accessible through increasingly profound meditative absorption.

From birth up through death, every moment of every existence is uninterruptedly accompanied by activities of consciousness. And the range of possible "ebullitions" is very great. It stretches from extremely dull and extremely painful states up to states of indescribable joy and clarity. The purpose of a spiritual path, in this case the Buddhist path, is to make use of unawakened faculties, and to exploit them to the fullest in a positive direction. In Great Vehicle Buddhism, the final goal to be aimed at is buddhahood, by which is meant the perfect realization of everything that consciousness is capable of achieving. It is also described as "knowing whatever there is to know" (*ji-snyed-pa rtogs-pa'i ye-shes*), which means that ignorance, and all suffering that arises from it, has thereby automatically come to an end.

As already mentioned, the realization of buddhahood is described,

among other things, as the gaining of the various bodies of an enlightened being, of a buddha. By these we do not mean physical bodies, but the various aspects of the qualities and capabilities of a buddha. Accordingly, for each enlightened body there are, depending on the point of view and function, various terms and classifications.

In the Panchen Rinpoche's text, two are mentioned. Of course, in reality it is not possible, at the stage of buddhahood, to distinguish different kinds of enlightened bodies. The impossibility of doing so is indicated in the following couplet:

> As far as [a buddha's] wisdom extends,
> So also [his] enlightened body extends.[41]

Nevertheless, for the sake of addressing those practitioners whose thinking and imagination are still limited by human conceptions, i.e., for didactic reasons, certain distinctions are made:

1. Form Body (*gzugs-sku,* Skt. *rūpakāya*), enlightened body in relation to form;
2. Truth Body *(chos-sku,* Skt. *dharmakāya*), enlightened body in relation to mind, further divided into:
 a. Wisdom Truth Body (*ye-shes chos-sku,* Skt. *jñāna-dharmakāya*);
 b. Nature Body (*ngo-bo-nyid-sku,* Skt. *svabhāvikakāya*).

Here, the Wisdom Truth Body and the Nature Body are merely distinct aspects of the Truth Body, namely, its wisdom and its purity. Again, the mirror symbolizes the Wisdom Truth Body, because it simultaneously and without distinction reflects all phenomena. It likewise symbolizes the Nature Body, because it is clear and free from pollution. If we offer the mirror with all these accompanying thoughts, this action causes an impression to be stored in the subtle consciousness which, together with many other similar impressions, will finally lead to the offerer's own realization of the bodies of a buddha, i.e., buddhahood.

This concludes my explanation from the perspective of Tibetan Buddhist practice. As regards the remaining symbols, in each case a portion of text will be translated and briefly commented on as far as necessary.

THE GHIWANG [MEDICINE]
ཁྱི་ཝང་།
(ghi-wang, Skt. gorocanā)

GHIWANG IS NOT a Tibetan word, but was borrowed from the Chinese. *Ghi'u* means "cow" and *wang* (sometimes spelled *dbang*) means "essence." It is a substance of animal origin, in fact a kind of gallstone found in cattle, which is used to this day in Tibetan medicine. *Standards in Tibetan Medicine* (*Bod-sman-gyi tshad-gzhi*), a handbook published in 1979 by the Health Service of the Autonomous Region of Tibet and Five Other Regions, states under the heading for *Ghiwang:*

> This medicinal substance is a gallstone from the ox, cow, dri (*'bri*), and yak (*g.yag*). If *ghiwang* is found in a slaughtered animal, the gall liquid should be drained off and it should be removed, the outer skin taken off, and it should then be dried.

After a full description of its appearance and qualities, its use is explained:

> In connection with other substances it brings about clear thoughts, helps against fever, mucous secretion, nervousness, and assists the functioning of organs, helps against poisoning, fainting fits, mental disturbances, childish fears and boils.[42]

Monier-Williams has under *gorocanā:*

> A bright yellow orpiment prepared from the bile of cattle (employed in painting, dyeing, and in marking the Tilaka on the

forehead; in medicine used as a sedative, tonic, and anthelmintic remedy).[43]

It is, therefore, a calming and strengthening medicament widely used in Asia. Owing to its reputed beneficial effect on the nervous system, and thus indirectly on one's psychic well-being, it may be understandable why, of all medicinal substances, *ghiwang* came to be counted among the Eight Bringers of Good Fortune. And due to the difficulty of obtaining it, it is naturally precious.

As regards its symbolic meaning, *An Explanation of Auspicious Substances and Symbols* offers the following explanation:

> *Ghiwang* is a sign (*rten-'brel*) for realizing the perfection of benefit for others. The immeasurable activities of the buddhas are a distinctive feature (*khyad-chos*) of tantra. Among these activities there are four particular kinds: peaceful activities, and those of increase, power, and wrath. Of these, the peaceful activities uproot all sicknesses that have arisen from the three poisons (*dug-gsum*), and they speed up the development of wisdom realizing emptiness (*de-kho-na-nyid rtogs-pa'i shes-rab*)...For this reason, *ghiwang* is offered to the Buddha.[44]

The three poisons are the spiritual poisons of attachment (*'dod-chags*, Skt. *rāgā*), hatred (*zhe-sdang*, Skt. *dveṣa*), and delusion (*gti-mug*, Skt. *moha*), which, according to Buddhist teaching, are the cause of all suffering. The detoxifying effect of *ghiwang*, therefore, is equated with the removal of mental poisons in the religious sense. The spiritual "detoxification"—like the physical—only works when the medicine is applied; what this means in a spiritual context is that the substance must be offered with proper motivation.

Here again we see how the "elimination of bodily suffering" has transformed into the "elimination of all suffering." By expanding the scope of the concept, one has at the same time shifted to a different—a deeper and more pervasive—level of understanding. Thus, one is no longer merely concerned with the relief of passing disturbances but is instead focused on a final "cure."

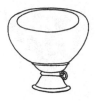

THE YOGURT

(zho, Skt. *dadhi)*

To THIS DAY IN INDIA, yogurt retains an important role in healthful nutrition. It also serves as an appropriate symbolic offering on account of its nature, its white color, and the manner of its production.

The recitation passages in the *Clear Mirror: A Condensed Recitation of a Consecration Ceremony [entitled] "Downpour of Goodness and Fortune" according to the tradition of the glorious Upper Tantric College (dPal-ldan stod-rgyud lugs-kyi rab-gnas dge-legs char-'bebs-kyi ngag-'don phyogs-bsgrigs gsal-byed me-long)* declare that it is a highly regarded product: "Yogurt is the essence of all substances."[45] This brief sentence, without further explanation, may sound a bit strange to us. But *An Explanation of Auspicious Substances and Symbols* indicates rather more clearly what this may mean:

> Yogurt is a sign of the abolition of [negative] actions (*las*) and defilements—
> - Milk is the essence of the concentrated juice (*bcud*) of plants. By a process of cooking, setting, and so on, it turns into yogurt.
> - In the same way, the mind, which by nature is clear and [provides] the basis of samsara and nirvana ('*khor 'das*), develops, through the process of the path, to the attainment of buddhahood...
>
> Just as clouds break up in the sky, so all contaminated (*dri-ma*) actions and defilements are dissolved in the mind. In this way, the pure essence (*nying-po rnam-dag*), the highest wisdom (*ye-shes-kyi mchog*), is realized. To bring this about, yogurt is offered.[46]

THE DŪRVĀ GRASS

རྩ་དུར་བ།

(rtsva dur-ba, Skt. dūrvā)

THE INDIANS HAVE ALWAYS regarded *dūrvā* grass as having a greater survival capacity than any other plant. They say that even if it has been cut and dried, every one of the many knots in its stem has the power to put out shoots if it comes into contact with water. And so *dūrvā* grass became the symbol of long life or of the wish for the extension of life. It is also very common in Tibet, where it has the same symbolic meaning as in ancient and modern India. *An Explanation of Auspicious Substances and Symbols* explains:

> *Dūrvā* grass is offered as a substance that prolongs life. In the *Immortal Treasury* (*'Chi-med-mdzod*) it is called *"dūrvā* with a hundred joints or knots (*tshigs*)."* Shoots grow from every one of these knots. It cannot be harmed by treading on it, cutting it, and so on…It is immortal like the vajra-being (*rdo-rje sems-dpa'*, Skt. *vajrasattva*)…The *dūrvā* substance brings about [symbolically] the end of the stream of birth and death of all beings (*'gro-ba yongs-kyi skye-'chi rgyun-chad-du byed-pa*).[47]

Monier-Williams mentions under *durmara* a kind of *dūrvā* grass in connection with a "hard death,"[48] and under *sahasra-vīrya*, *dūrvā* is mentioned in connection with "having a thousand energies."[49] What at first sight looks like a contradiction, namely, the meaning of *dūrvā* grass as a symbol of the lengthening of life in the conventional sense and, on the other hand, its religious meaning as a symbol of the ending of the stream of

birth and death, is in reality, from the Buddhist point of view, no contradiction at all. The underlying idea is this: in order to realize the highest goal of the practice, liberation from the compulsive repetition of birth and death, one needs time. The relation between this goal and long life is thus clear.

But why is vajra-being (or *vajrasattva*) mentioned in this connection? It says here: "It is immortal like the vajra-being…" And later on, in the recitation section, there is a passage: "…after *vajrasattva* has made life whole, may birth and death, (caused) by the defilements, cease!"

In order to grasp the hidden meaning, one has to understand that *vajrasattva* here does not mean the tantric meditational deity, upon whom one meditates in order to purify one's consciousness. *Vajrasattva* is also— and that is the meaning here—a term for the so-called ultimate *bodhicitta*, i.e., emptiness. As already explained in discussing the Eight Symbols of Good Fortune, the vajra is a symbol of indestructibility and imperturbability. The Sanskrit word *sattva* (Tib. *sems-dpa'*) means "being." The vajra-being is a synonym for emptiness as the ultimate nature of all phenomena. According to the teaching of the Buddha, the realization of emptiness is the only effective method of cutting off the ego-illusion and the grasping at objects, and thus the roots of cyclic existence.

But what is the connection between *vajrasattva* and the length of life? The wisdom realizing emptiness frees one's existence from all karmic fetters, hindrances, and painful, frightening states. On the normal human plane it is, therefore, the best antidote to life-shortening or life-threatening factors. But it is also a decisive step on the path to buddhahood, to the desired state of perfection, of complete liberation, of real life!

THE BILVA FRUIT

ཤིང་ཏོག་བིལ་བ།

(shing-tog bil-ba, Skt. bilva)

THE *BILVA* FRUIT HAS BEEN one of the favorite fruits in India throughout history, and still is. More precise explanations about its importance as an offering, which would likely explain just why this fruit came to be numbered among the Eight Bringers of Good Fortune, I have been unable to locate.

The words of *An Explanation of Auspicious Substances and Symbols* about this symbol are astonishingly profound:

> Bilva is a substance for the increase of merit (*bsod-nams*). As regards its dependent origination *(rten-'byung)* there are two [levels of expression], gross and subtle.
>
> The gross level [relates to] the confidence that from wholesome and unwholesome (*dge sdig*) causes, happiness and suffering (*bde sdug*) arise. That is the mundane pure view (*'jig-rten-pa'i yang-dag-pa'i lta-ba*). According to this, what is to be accepted and what is to be rejected *(blang dor)* should not be interchanged (*go ma-log*). These are the pure [worldly] actions (*yang-dag-pa'i spyod-pa*).
>
> The more subtle [presentation of] dependent origination [refers to the fact that] everything exists merely through the name, only by nominal imputation (*ming-rkyang btags-yod tsam*). There is not one single particle that exists by its own essence (*rang-gi ngo-bo*). Understanding this is the supramundane pure view (*'jig-rten-las 'das-pa'i yang-dag-pa'i lta-ba*). In these [two, therefore], method and wisdom are combined (*thabs-shes zung-'brel*). These are the supramundane pure actions (*'jig-

rten-las 'das-pa'i yang-dag-pa'i spyod-pa).

And thus the bilva fruit is offered, so that all these [views and actions up to the] highest essence of enlightenment (*byang-chub snying-po mchog*) may become purified.[50]

In these explanations there is mention of "dependent origination" (*rten-'byung*). This term, just like *tendrel,* or "dependent existence" (*rten-'brel*), describes the manner in which reality exists, namely: as a network of causes and effects, conditions, linkings, and namings. As a supplement to this we have explanations of how reality does not exist: it lacks any concreteness in itself, it is empty of self-essence. The doctrines of emptiness and conditionality both lead to the same understanding, but from two different points of view. The practitioner should, above all, aim to gain profound insight into emptiness/conditionality and thus eradicate suffering. The offering of *bilva* fruit is one of the innumerable methods in the context of Buddhist practice which are meant to remind the person making the offering of this goal, and to bring it closer to him or her through the process of practice and familiarity.

Depending on the point of view, two levels of presentation are distinguished here, one gross and one more subtle. The gross level points out the relation of cause and effect in a conventional sense; its aim is to utilize careful consideration in avoiding unwholesome, pain-causing actions and in strengthening wholesome actions, thus passing through a development that gradually leads away from suffering. At this level of explanation, there is no reference to the role played by the individual in perceiving and interpreting reality. Rather, everything is stated in terms of normal, everyday concepts.

In the more subtle presentation, the aim is to refute these concepts through "supramundane pure view." Phenomena are explained as being dependent on their nominal imputations, and thus empty of self-essence. The perfect realization of this insight automatically excludes pain-bringing actions bearing the mark of ignorance. This is taken so much for granted that the present text hardly bothers to describe the "supramundane pure actions." The unity of view and action, wisdom and method, is presented as a process of purification which leads to the "highest essence of enlightenment," i.e., to buddhahood.

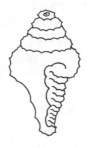

THE RIGHT-TURNING CONCH SHELL
དུང་གཡས་འཁྱིལ།
(*dung g.yas-'khyil,* Skt. *dakṣiṇāvartaśaṅkha*)

THE RIGHT-TURNING CONCH SHELL is a constituent of both the Eight Symbols of Good Fortune and the Eight Bringers of Good Fortune. Its religious meaning is the same in both groups: it expresses the wish that the Buddhist teaching may penetrate in all directions like the sound of the conch trumpet.

An Explanation of Auspicious Substances and Symbols says:

> The right-turning conch shell is an object for the increase of the qualities of abandoning and attaining (*spangs rtogs*), and of the wealth of Dharma (*chos-kyi dpal-'byor*). Through being offered, it functions as a sign for hearing the secret essence of spoken words (*gsung-gi gsang-ba'i gnad*). The meaning of this hearing is that, through reflection, doubts are cut off and wisdom arises from meditation (*sgom-byung-gi ye-shes*). Thereupon, one [can] teach others: that is the "unsurpassable language" (*smra-ba bla-na med-pa*). In this way, one realizes buddhahood. Thus, through the beautiful sound of Dharma, the activities of explanation and realization (*bshad sgrub*), the path and the fruition (*lam 'bras*), are completely shown. The conch shell is [also] a sign that, through [the beautiful sound of Dharma], everything that does not correspond to Dharma pales beside its splendor (*zil-gyis gnon-pa*).[51]

Among other things, this section treats the three trainings of hearing or study, thinking or reflection, and meditation (*thos bsam sgom-pa*) through

54

which, if one practices them intensively, perfectly, and in this order, one becomes qualified as a teacher who has command of the "unsurpassable language." That is to say, one teaches, not from intellectual knowledge, but from realization. The "beautiful sound of Dharma," meaning the oral transmission of the teaching, thus gains its full quality and validity. In view of this, the conch shell is described as a symbol for increase in the quality of the wealth of Dharma.

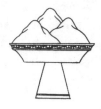

THE CINNABAR

(li-khri, Skt. *sindūra)*

CINNABAR IS A NATURAL PIGMENT which is often used for ritual purposes, e.g., for painting the *tilaka* on one's forehead. It is also used for making certain mandala diagrams and as paint. When offered in powder form it is considered as a symbol of power, owing to its strong red color.

In general color symbolism, which also lies behind the creation of tantric mandalas, the following symbolic connections apply:

1. White: peace, purity
2. Yellow: increase, wealth
3. Red: power, love, attachment
4. Green: various activities
5. Blue/black: wrath, pollution

In a similar way, connections are established between forms, points of the compass, sounds, attributes, and so on. More details about these will be given in the section on the Five Qualities of Enjoyment.

What is meant by "power" in this context is explained in *An Explanation of Auspicious Substances and Symbols* as follows:

> Cinnabar [symbolizes] the realization of the activities of power (*dbang-gi las*). In his explanations, the Buddha has dealt with the activities of power. If one practices faultlessly in the right way, one will completely command all forms of Dharma (*dbang-du-'dus*). Through the power of realizing special qualities, such as super-normal awareness (*mngon-shes*), through concentration

(*ting-nge-dzin*), and so on, all kinds of outer and inner dishar-
mony (*phyi-nang-gi mi-mthun 'phyogs*) pale beside its splendor.
In order to strengthen the kingdom of Dharma (*chos-kyi rgyal-
srid*) and the dominion of knowledge (*mkhyen-srid*), cinnabar is
offered.[52]

In other texts with similar descriptions, instead of "dominion of knowl-
edge" (*mkhyen-srid*), we find "your dominion" (*khyed-srid*).

The concept of power is used—raised to the mental level—in the sense
of control over one's own capacities and powers, and also command of
knowledge and wisdom.

It must be said, however, that in this explanation, the magic of power
seems a bit bloodless. Much more forceful sounding is a prayer that is often
expressed in connection with mantra recitations: "May all living beings,
male and female, come under my power, likewise all foods, riches, and
enjoyments of the three realms!"

But how does that fit in with the peaceable Buddhist way of thinking?
All of these seemingly worldly aims can, of course, be associated with the
Great Vehicle motivation, and thus ennobled. As practitioners, we need a
minimum of material goods, health, and a long life in order to pursue our
religious aims and help suffering beings. However, it is possible to exagger-
ate and, while mouthing phrases about the welfare of all beings, to really be
aiming at the satisfaction of egoistic wishes, thereby misusing spiritual
instruments. Although this might be temporarily effective, according to the
Buddhist explanation of karma, it carries unpleasant consequences for one
who acts in this manner.

Such prayers and recitations which deal with power, increase, and wrath
are often very ancient, and remind us that the tantric tradition goes back to
a time when magic was, as a matter of course, employed for the satisfaction
of basic needs, and in the service of survival, victory, and domination. The
fact that, when joined to the Buddhist teaching, much is interpreted
afresh—and no less powerfully—presents no contradiction.

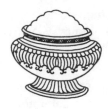

THE MUSTARD SEEDS
ཡུངས་ཀར་

(yungs-kar, Skt. *sarṣapa)*

THE MUSTARD SEEDS are regarded as "wrathful substance," and are connect-
ed with the wrathful activities of a buddha (see p. 42). They are frequently
used in rituals. For instance, in the ritual for the expulsion of hindering
demons (*bgegs-gtor*),[53] the practitioner scatters mustard seeds while reciting
the mantras. Also, as a means of prevention or cure of obsession or disease
caused by hindering demons (*bgegs*), mustard seeds are burned after being
blessed by special mantras and meditative visualizations. They have a simi-
lar function as offerings in the burnt-offering ceremony (*sbyin-sreg,* Skt.
homa). Altogether, therefore, they symbolize wrathful activities for over-
coming hindrances.

An Explanation of Auspicious Substances and Symbols says:

> Mustard seeds are an object for the realization of wrathful activi-
> ties (*drag-po'i phrin-las*)... By offering them [the following is
> effected]: The root of all the harmful and hindering demons (*gdon
> bgegs*) and disturbances (*nyer-'tshe*) is ignorance that is taken for
> truth (*bden-'dzin*). In order to destroy [ignorance], the supreme
> antidote is the wisdom of the *Dharmadhātu* (*chos-kyi dbyings-kyi-
> ye-shes*) which is non-dual bliss and emptiness (*bde-stong gnyis-su
> med-pa*), the self-illuminating glory (*rang-mdrangs*) of Akṣobhya.
> Through this, all outer, inner, and secret (*phyi nang gsang*) harm-
> ful and hindering demons are mixed with the sphere (*dbyings*)
> [of the buddhas] and the [ordinary] consciousness (*rig*), and thus
> the great sameness wisdom (*mnyam-nyid ye-shes*) is acquired
> without effort. [For this purpose] mustard seeds are offered.[54]

The demons and hindrances that thus exist through, or in the form of, ignorance are phenomena which belong to the realm of the normal, unpurified consciousness (*rig-pa*). The completely purified consciousness which develops out of that ordinary consciousness is the sphere (*dbyings*), or wisdom, of the buddhas. The perfect realization of this is often described in the texts as non-duality or the fusion of ordinary consciousness and the sphere of the buddhas. At this point, ignorance has been abolished, and, thereby, the arising of hindrances or demons has been automatically overcome.

"Wrath" in the sense of a buddha's activities is, of course, not an aggressive attitude in the conventional sense, but a particularly powerful expression of mental powers. In the same way, the practitioner should not imagine the destruction or annihilation of demons as denoting hostility or murderous intentions towards other beings, but as the overcoming of the hindrances, thus symbolized, in one's own consciousness. This, at any rate, is how it is taught in the context of Buddhist practice.

However, if we consider rather more closely what the term "demon" has always meant in Indo-Tibetan culture, this psychological explanation may become more doubtful. One is then easily tempted to regard these demons as living beings, which at once raises the question of what kind of beings they are. We can get some idea of this by considering the four best-known types of demon (*bgegs*, Skt. *vighna*; *gdon*, Skt. *graha*; *'dre*, Skt. *piśaca*; *bdud*, Skt. *māra*), and comparing a few definitions from (a) the Tibetan-Chinese dictionary[55] and (b) Böhtlingk's Sanskrit dictionary:[56]

(a) *Tibetan*	(b) *Sanskrit*
bgegs: a malicious kind of *'dre / gdon*	*vighna:* blockage, obstacle, hindrance
gdon: a non-human worker of harm	*graha:* a demon of sickness, an evil demon who gains power over a person
'dre: a category of non-human beings	*piśaca: a* class of demonic beings…
bdud: one who causes harm and disturbance to living beings and puts obstacles in the way of merit / one of the six forms of desire realm god	*māra:* Hindrance; the Buddhist tempter

Furthermore, in the *Bod-hor-kyi brda-yig min-gcig don-gsum gsal-bar byed-pa mun-sel sgron-me* of Sumatiratna,[57] there are references to outer, inner, and secret *bdud,* the outer ones being causes of harm in the traditional sense, but the inner ones being the two kinds of obstruction (*sgrib-pa gnyis*), and the secret ones, the gross and subtle winds of karma (*las-rlung phra-rags*). These various levels are also treated in great detail in the *Man-ngag rin-po-che spungs-pa* of Jeygom Dzongpa (*lCe-sgom-rdzong-pa*).[58]

Obviously there is a great range of varied explanations, some seeing the demons as non-human beings and assigning them to the realm of hungry ghosts, or *pretas* (*yi-dvags*), or to a class of gods of the desire realm (*'dod-lha,* Skt. *kāmadeva*), while others describe them quite generally as outer and inner hindrances, unfavorable circumstances, or even as the basic conditions of a sorrowful existence.

To comment on these explanations is not possible within the framework of this study, but it would be quite rewarding to make them the subject of special investigation. It would be especially important to clarify the question of whether, how, and when the image of the demons changed so much in the course of centuries under Buddhist influence that the ideas of enmity, harm, and violence became transformed into an analysis of one's own consciousness.

In explaining the symbol of the mustard seeds, *An Explanation of Auspicious Substances and Symbols* mentions the terms *gdon* and *bgegs*. In accordance with current usage in Tibetan-speaking areas, they are here rendered as "harmful demons" (*gdon*) and "hindering demons" (*bgegs*).

The offering of mustard seeds as an antidote to these demons is again connected with ideas from the realm of tantra, which make them effective on a higher level. In this connection, Akṣobhya is mentioned as a member of the five buddha families, along with two of the five wisdoms that are assigned to these families, namely: wisdom of the *Dharmadhātu* and wisdom of equality.

HOW THE EIGHT BRINGERS OF GOOD FORTUNE ARE USED

Thus far we have seen the explanations of the individual signs forming the Eight Bringers of Good Fortune. Explanations similar to those in *An Explanation of Auspicious Substances and Symbols* can be found in *bKra-shis rdzas-brgyad-kyi rnam-bshad bkra-shis dga'-ston* by Gungtang Könchok Tenpai Drönme (*Gung-thang dKon-mchog-bstan-pa'i-sgron-me*),[59] with even fuller references to the Buddhist background.

The Eight Bringers of Good Fortune are frequently used in sculptures or pictures, e.g., as figures on painted scrolls, on walls and beams, as butter

ornaments on sacrificial cakes (*gtor-ma*), and so on.

In rituals, they are offered symbolically or actually, accompanied by citation and chanting in alternating strophes. The citation is made by the leader of the ceremony alone, while the actual chanting text is recited by all together. This form of offering, usually complemented by symbolic hand gestures (*phyag-rgya*, Skt. *mudrā*) and meditative visualization, is one component of the long-life ceremony for a lama (called "firmly remaining") and also of the ritual for calling down a blessing (called "perfect dwelling"). In many rituals, both the Eight Symbols of Good Fortune and the Eight Bringers of Good Fortune are used; but the Eight Symbols occur only within the context of the chanting of texts, more in the sense of general wishes for luck and blessings, whereas the Bringers of Good Fortune, as described above, occur with citation and chanting, and often with actual offerings, thus forming an independent constituent of the ceremony.

The following verses are from the *Clear Mirror*.[60] But there are many similar texts still in use, which vary slightly according to the purpose of the ritual and the particular school or monastery. The basic text is possibly Ratnaśila's *rDo-rje rnam-par 'joms-pa zhes-bya-ba'i [gzungs] dkyil-'khor-gyi lag-len go-rims ji-lta-ba zhes-bya-ba* (Skt. *Vajravidāraṇā-nāma-dhāraṇī-maṇḍala-prakriyā-yathākramanāma*), which is the oldest text of this kind known to me. For easier reading, only the name and function of the offerer and the offered object to be substituted in the verse are mentioned from the second stanza on.

> Previously, ||:the goddess of form, Öchangma,:|| gave ||:a mirror:|| into the hand of the blessed one, Śākyamuni, and he blessed it as an object of good fortune. In the same way, may the donor and the donor's household obtain good fortune here and now through the mirror(-object).

> Through this good fortune of enjoying, unhindered, completely pure phenomena—which, through the mirror [as a sign] of the great wisdom ocean [itself], have been purified in the excellent wisdom ocean—may the obstructions also be purified.

> …the elephant, Norkyong…*ghiwang* medicine…

> *Ghiwang* is a (sickness-)medicine for abolishing the three poisons. Through this good fortune of liberating from the

pains of the defilements, which is perfectly realized through the essence of phenomena as the best medicine, may suffering also be purified.

...the farmer's daughter, Lekgyema...yogurt...

Yogurt has become the essence of everything. From the essence, the highest realization of absolutely pure wisdom, it has become the sphere of all qualities. Through this good fortune, may the three poisons also be abolished.

...the grass seller, Tashi...*dūrvā* grass...

Dūrvā lengthens life. Out of the perfect realization of the life of the vajra-being, the continuity of birth and death based on the defilements has ceased. Through this good fortune, may life also increase.

...the god, Brahmā...a *bilva* fruit...

Bilva [symbolizes] phenomena [in connection] with cause, occasion, and fruit. May all kinds of mundane and supramundane behavior be purified in the essence of the highest enlightenment. Through this good fortune, may all requests also be fulfilled.

...the ruler of the gods, Indra...a right-turning conch shell...

Just as the conch proclaims the sound of the Dharma, one will become pure in the wisdom ocean and proclaim the Dharma without error and completely. Through this good fortune, may eloquence also be obtained.

...the brahmin, Kargyel...cinnabar...

Cinnabar symbolizes the nature of power. When all phenomena without exception have been brought under one's power, the royal power of the Dharma will be quite firmly established. Through this good fortune, may your rule also be firm.

...the glorious Vajrapāṇi, lord of the secret mantras and mantras of knowledge...mustard seeds, the substance of realization...

Mustard seeds [symbolize] the vajra family. At all [times] they have possessed the perfect quality of the power to destroy all the hindering demons. Through this good fortune, may the hindering demons also be pacified.[61]

རྒྱལ་སྲིད་རིན་ཆེན་སྣ་བདུན།

3

THE SEVEN JEWELS OF ROYAL POWER

རྒྱལ་སྲིད་རིན་ཆེན་སྣ་བདུན།

(rgyal-srid rin-chen sna-bdun, Skt. *saptaratna)*

THE SEVEN JEWELS OF ROYAL POWER embrace the following objects and persons:

- the Precious Wheel
- the Precious Jewel
- the Precious Queen
- the Precious Minister
- the Precious Elephant
- the Precious Horse
- the Precious General

This is the usual list, but there are others which give "the householder" instead of "the general" in the seventh place.

These symbols too are mentioned in the canonical literature.[62] As regards the meaning of the various signs, the texts give various explanations, some of which concentrate chiefly on the Buddhist interpretation, while others are still clearly derived from the original, strongly magical, meaning of the signs in the cultural context of the ancient Indian tradition. The principal text I will draw on here for description of the signs, *Mindful Establishment of the Excellent Dharma* (*'Phags-pa dam-pa'i-chos dran-pa nye-bar gzhag-pa* Skt. *Āryasaddharmānusmṛty-upasthāna*),[63] belongs to the latter group. In reading this text, one notices that the symbols are arranged in the order "queen, jewel, wheel, elephant, horse, minister, householder," instead of the more usual arrangement shown above. No reason is given for this.

The Seven Jewels of Royal Power form the accoutrements of a *cakra-vartin* (*'khor-los bsgyur-ba'i rgyal-po*), a symbolic figure from pre-Buddhist times, generally referred to as a "universal monarch."[64] *Cakravartin* means "wheel-turner." His name, therefore, echoes the multiple symbolism connected with the wheel. The Tibetan compound consists of "wheel" (*'khor-lo*) plus a verb (*bsgyur-ba*) which, in normal usage, means something like

"turn," "set in motion," but also "change," "rule or reign over," "adminis-ter," etc. The meaning is a king whose rule is connected with a wheel. If we take into account the various meanings and levels of meaning associated with the wheel symbol (see p. 30), *cakravartin* can be a ruler through the wheel, with the wheel, or over the wheel. The meaning of this will be explained below. The wheel plays such an important role that, in the tradi-tional list of the Seven Jewels of Royal Power, it is put first.

As regards the tantric meditational deities (*yi-dam*, Skt. *iṣṭadevatā*) *Kālacakra* and *Cakrasaṃvara*, the wheel (Skt. *cakra*) forms part of their name and thus indicates that their pure activities in their domain develop extensively and without hindrance. The texts contain profound tantric explanations of this which I shall not enter into here.

As a group of people, animals, and things, the seven objects collectively symbolize the aids and faculties with which a secular king can gain and maintain power. They give him knowledge, power, and resources. In the Buddhist interpretation, a comparison is drawn between the outward rule of a secular king and the inward, spiritual power of a practitioner, in which the Seven Jewels receive an esoteric meaning. By means of the Seven Jewels, the characteristics and qualities of the practitioner are symbolically represented: boundless wisdom, invincible power over all inner and outer obstacles, and inexhaustible spiritual resources. The analogy, familiar in the Indo-Tibetan cultural sphere, between secular and spiritual rule (to which the use of titles of honor like "Dharma king" also points) is also an injunction to the medita-tor to recognize the connection between outward and inward reality.

Mindful Establishment of the Excellent Dharma[65] mentions this. According to its explanations, if one renounces negative mental states (*gnod-sems*), one will gain various positive results in the next life, and will finally be reborn as a *cakravartin*, equipped with all the Seven Jewels.

The frequently mentioned connection between a buddha and a univer-sal monarch, between the highest possible spiritual and worldly levels, is also seen in the statement of the augurs at the birth of Prince Siddhᵣrtha: Either he will become a great world-ruler, i.e., a *cakravartin*, or else, if he chooses homelessness and the life of a monk, he will gain enlightenment and become a buddha.[66]

The general Tibetan practice of investing persons in religious orders with worldly offices (as in the institution of the Dalai Lama) can be seen *inter alia* as an outward expression of the attempt to equate worldly and spiritual rule.

THE PRECIOUS WHEEL

འཁོར་ལོ་རིན་པོ་ཆེ།

('khor-lo rin-po-che, Skt. *cakraratna)*

AS AMONG THE EIGHT SYMBOLS of Good Fortune, here also the wheel is understood to be an extremely powerful sign, representing among other things:

- a weapon, instrument, or vehicle through whose qualities and possibilities the rule of the *cakravartin* is established and maintained;[67]
- a symbol of his movement, mobility, his reach, and thus the extent of his territorial claims;
- the sun as a "royal emblem";[68]
- the realm ruled over by the *cakravartin*—his kingdom;[69]
- the wheel of Buddhist doctrine, from which a symbolic equation of *cakravartin* and buddha can be deduced.[70]

Mindful Establishment of the Excellent Dharma describes it in great detail:

The precious wheel possesses five evident qualities:

First, it is made of gold from the River Dzambu (*'dzam-bu'i chu*), it measures five hundred *yojana* (*dpag-tshad*),[71] and it has a thousand spokes. It is as beautiful as a second sun in the world...

Second, in a single day, it rolls unhindered for a hundred thousand yojana through the sky.

Third, wherever the *cakravartin* wishes to go—to the [continents of] Balangchö (*ba-lang-spyod*) in the west,

Lüpak (*lus-'phags*) in the east, Draminyen (*sgra-mi-snyan*) in the north, [or] the divine realm of the four great kings (*rgyal-chen bzi'i lha-gnas*)—he goes there in the sky (*nam-mkha'-la*) with the aid of the thousand-spoked wheel. Through its power, he can ride the length of the sky with the four sections of his army: elephants, cavalry, chariots, and infantry.

Fourth, with its help, the *cakravartin* can hear the inaudible.

Fifth, it overcomes all resistance. To the king who possesses the Dharma and follows the Dharma, kings and ministers submit (*'thams-cad 'bul-te,* literally, "offer everything") as Dharma friends[72] as soon as they see him.[73]

The "great kings of the four realms" are the guardians of the four quarters, as described by Rigzin[74] and illustrated in *Tibetan Religious Art.*[75]

In view of the powerful descriptions of *Mindful Establishment of the Excellent Dharma,* one might wonder what lies behind them. They can be supplemented by the religious explanations of *Analysis of the Cause* (*rGyu gdags-pa,* Skt. *Kāraṇa-prajñapti*):

In the manner of the *cakravartin's* precious wheel, so should one consider the eight steps of the noble path of the Thus Gone (*de-bzhin-gshegs-pa,* Skt. *tathāgata*), the foe destroyer (*dgra-bcom-pa,* Skt. *arhat*), the perfect buddha (*yang-dag par rdzogs-pa'i sangs-rgyas,* Skt. *samyak-sambuddha*). Through getting rid of the defilements and obstructions with regard to all phenomena, the blessed one (*bcom-ldan-'das*) has realized the eight steps of the noble path. Just as the king, with the aid of the wheel, has conquered the entire earth, so too the Buddha, through the power of the path, has cut through the bonds of the demons (*bdud,* Skt. *māra*).[76]

The symbolic equation of *cakravartin* (who turns the wheel) and the Buddha (who has, likewise, set in motion the wheel of Dharma) is easy to follow. The possessor of unlimited worldly power and the possessor of unlimited spiritual power are, from the point of view of Buddhist practice, coded terms for the aim of the practitioner—to overcome all limitations, to discover the non-separateness of outer and inner, and, within this expanded reality, to experience oneself as the shaper.

The wheel, as a symbol of motion, is often compared in Tibetan literature with Dharma activities. There is mention of the three wheels (*'khor-lo gsum*), one of which is study (actually reading) in connection with hearing and reflection (*klog-pa thos-bsam-gyi 'khor lo*); the second is concentration on the basis of abandoning (*spong-ba bsam-gtan-gyi 'khor-lo*); and the third is action in the form of activities (*bya-ba las-kyi 'khor-lo*).[77] This reminds us of the three trainings, previously mentioned in our discussion of the wheel as one of the Eight Symbols of Good Fortune (see p. 30).

THE PRECIOUS JEWEL

ནོར་བུ་རིན་པོ་ཆེ།

(nor-bu rin-po-che, Skt. *maniratna)*

THIS SYMBOL IS SHAPED rather like an egg, or a triangle with rounded points. It is usually shown with the point upwards, and often three or more are put together as a group. All explanations of its meaning revolve round the concepts of wealth, increase, and unfolding: wish-fulfillment in the widest sense. It symbolizes the plenitude of power and possibilities for the *cakravartin.*

According to *Mindful Establishment of the Excellent Dharma:*

> It possesses the following eight properties:
> First, it shines in the night. Just as the harvest moon gives a clear light in autumn, so the jewel shines for a hundred *yojana* in the dark night. If, in daytime, one suffers from the heat, a bright light comes from it and overcomes the heat.
> Second, if one is travelling without water and suffers from thirst, a great river that possesses the eight qualities appears and quenches all thirst.
> Third, whatever the *cakravartin* thinks of arises out of the jewel.
> Fourth, from each of its eight parts, or members (*yan-lag*), at the right time (*de'i tshe*), light of various colors radiates, such as light of blue and yellow and white and red and crimson (*btsod-kha*) color.
> Fifth, wherever the jewel is, for about a hundred *yojana* round, there is no sickness. The mind remains always in a

state of equanimity. As with karmic actions, none of his wishes will go without result.

Sixth, it prevents evil *nāgas* from causing terrible rainfall.

Seventh, sadness, abysses, solitary regions, trees, ponds, gardens, lotuses, forests, and parks are [in a positive sense] perfected.

Eighth, nobody experiences untimely death [or] becomes an animal. [To none] is harm done by animals. Not even the disharmonious harm each other, as, for example, the snake and the mongoose.[78]

According to the religious explanation of *Analysis of the Cause*, "Just as a *vaidūrya* jewel shines throughout its surroundings, so too a buddha recognizes the surroundings with his eyes."[79]

With the aid of his jewel, a *cakravartin* can see and obtain everything. In the same way, a buddha can recognize everything, both conventional reality and ultimate reality, with all their interconnections. Thus, it is said that only a buddha, on the basis of his perfectly developed spiritual faculties, can recognize the individual connections of cause and effect in the network of karma. This is the kind of seeing meant here.

THE PRECIOUS QUEEN
བཙུན་མོ་རིན་པོ་ཆེ།
(btsun-mo rin-po-che, Skt, rāñiratna)

THE PRECIOUS QUEEN EMBODIES the complementary feminine pole without which the *cakravartin* cannot be imagined. The balance between the masculine and feminine elements, and sexual symbolism generally, form an essential factor of the tantric tradition. That the "masculine" and "feminine" figures are merely aspects of consciousness, and not persons, can also be seen in tantric mandalas, where the central principal deity together with partner is often counted as a single deity.

In the explanations of *Mindful Establishment of the Excellent Dharma*, the spiritual qualities of the precious queen as a symbol are mixed with the idealized image of a woman in the Indian culture of the time:

> From the body of the woman streams a perfume with the scent of sandalwood, and from her lips arises a perfume of the *utpala* flower…When the *cakravartin* sees such a woman, it becomes warm in a cold time and cool in a hot time. No one else dares to touch her. All people who, through the power of abandoning, resist negative mental states, practice meritorious activities, and who recognize all merits as pure, regard her as a mother and a sister. As for her, she has penetrated into the king's heart (*yid-du 'ong*) and she respects him; she always follows whatever he has in his heart (*snying-du sdug-pa*) and does whatever makes him happy. She renounces the five faults of a woman: thinking of other men, miserliness, attachment to what is unfitting (*mi-rigs-par chags-pa*), fondness for unsuitable objects (*mi-rigs-pa'i gnas-la rjes-su dga'-ba*), and having [the thought] of killing her

husband. She possesses the following five qualities of a precious woman: she adapts her thoughts, will bear many sons, has a harmonious nature (*rigs*), elevates the kingdom (*srid*), and is not jealous if her husband thinks of other women. She has the following three qualities of a great woman (*bud-med chen-mo*): she [speaks] no foolish words (*tshig cal-col*), holds no wrong views, and in the absence of her husband is not dependent on sounds, perfumes, taste, and touch.[80]

Analysis of the Cause remarks, "Just as the king's queen has penetrated to his heart (*yid-dug 'ong-ba*) and is lovely to look at (*lta-na-sdug*), so likewise is perfect joy a factor of enlightenment of the glorious Gautama."[81]

The qualities, abilities, and achievements of a buddha are grouped together in the literature in ever new combinations. One such grouping is that of the "seven factors of enlightenment" (*byang-chub yan-lag bdun*, Skt. *sapta bodhyaṅga*) alluded to here. These are the seven factors of: (1) perfect mindfulness, (2) perfect wisdom thoroughly distinguishing phenomena, (3) perfect (joyous) effort, (4) perfect joy, (5) perfect pliancy, (6) perfect concentration, and (7) perfect equanimity.[82] The fact that the precious queen is seen as a symbol of perfect joy is undoubtedly connected with the sexual symbolism often used, in the Indo-Tibetan tradition, to denote non-conventional states of consciousness.

THE PRECIOUS MINISTER

\glossary{}

(blon-po rin-po-che, Skt. pariṇāyakaratna)

THE PRECIOUS MINISTER EMBODIES the ability of the *cakravartin* to transform his thoughts and wishes into reality without let or hindrance, and without delay. As explained in *Mindful Establishment of the Excellent Dharma:*

> The qualities of the precious minister are these: Whatever the king has in mind in regard to various activities, even if he has not yet given any instructions, (the minister) knows it in his mind and carries it out (literally, "dedicates it entirely to the king"). Completely working actively (*bsags-pa*), without attachment, he avoids everything that is not in accordance with Dharma, does what is right (*shin-tu rigs-pa*) at the right place, at the right time, without complications (*nyon-mongs-pa med-pa*), without harming anyone, without disturbing a single person. When he is [performing actions] whose nature can be described as perfectly pure (*yang-dag-pa'i tha-snyad-dang ldan-pa'i rang-bzhin*) he does not tire. His wishes are directed to the various activities of the king, or to actions in aid of Dharma. Whatever is to be done in the future, he will offer (i.e., perform) completely.[83]

This is supplemented by the religious explanation of *Analysis of the Cause:*

> "Just as the minister knows [the king's intentions], and also reflects on their meaning, so too the Buddha, the blessed one, by his wisdom, cuts through the bonds of the demons."[84]

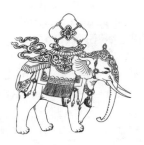

THE PRECIOUS ELEPHANT

གླང་པོ་རིན་པོ་ཆེ།

(glang-po rin-po-che, Skt. hastiratna)

THE ELEPHANT, AS ONE OF the mightiest of animals, symbolizes the power and strength of the *cakravartin*, which is combined with kindness, cleverness, and self-control. Thus, he is described in *Mindful Establishment of the Excellent Dharma* as follows:

> He is clever and very obedient, and conquers all opposing armies. He has seven limbs (*yan-lag bdun*). He is well provided (*legs-par gnas-pa*) with four legs (literally, "arms and legs"), a tail, a scrotum at the position of the genitals (*rlig-pa 'doms-kyi gnas-na 'dug-pa*) and a trunk. By nature (*rang-bzhin*) he possesses the strength of a thousand elephants. Therefore, he is of beautiful appearance and white in color like snow and silver, just like the elephant of Kāuśika (*brgya-byin*). The other elephants do not [and cannot] remain when they have caught his scent (*dri tshor-ba*). He fights in three places: in the water, on dry land, and in space. With his perfect strength (*shugs phun-sum tshogs-pa*) he can, in a single day, circle [the continent of] Dzambuling (*'Dzam-bu-gling*) three times. He is led by just a single cord. When the *cakravartin* rides the clever elephant, the latter follows his [master's] mind directly. Wherever the *cakravartin* directs his thoughts, the elephant goes there without any instructions. His step is calm and majestic, with fine movements (*spyi-bor bskyod-pa*), without disruptions (*gnod-pa*) or shocks (*'khrug-pa*), fine looking and beautiful. If he goes among children, he does not frighten them. When he goes around in

narrow streets and crossings, or [even] among cupolas (*ba-gam*), women too can endure his sight. When he fights, in anger, [he can still] be led by a cord.[85]

The elephant is described as "the one with seven limbs" (*yan-lag bdun-ldan*). I can find no explanation in the literature or in popular tradition for stressing this.

The translation to the religious level, in *Analysis of the Cause*, is as follows:

> Like unto the precious elephant of the *cakravartin*, so should one regard the four miraculous achievements (*rdzu-'phrul-gyi rkang-pa bzhi*, Skt. *catvāri ṛddhipāda*) of the Thus Gone, the foe destroyer, the perfect buddha; for the blessed one has, through these four kinds of miraculous achievement, removed all defilements and gained [knowledge] of all phenomena, free of obstructions.[86]

Just as it symbolizes the powers of the *cakravartin*, so also does the elephant stand as a symbol for the unlimited capabilities and powers of the Buddha: miraculous aspiration, miraculous effort, miraculous intention, and miraculous analysis.[87]

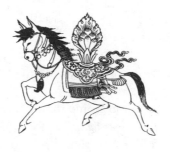

THE PRECIOUS HORSE
རྟ་མཆོག་རིན་པོ་ཆེ།
(rta-mchog rin-po-che, Skt. *aśvaratna)*

THE PRECIOUS HORSE SYMBOLIZES the mobility and speed of the *cakra-vartin*, and is, at the same time, his personal mount. The horse plays an altogether important part in pre-Buddhist[88] and Buddhist symbolism. It is represented in innumerable variations, which are often confused with one another. Therefore, it is not surprising that, as regards his outward appearance, the precious horse is described by *Mindful Establishment of the Excellent Dharma* and *Analysis of the Cause* in quite different terms.

In *Mindful Establishment of the Excellent Dharma*, we find the following explanations:

> The precious horse is white like a goose and the *kumuda* flower.
> The crown of his head, and so on, is completely adorned with
> beautifully colored heavenly jewels. His proportions, color, and
> form are perfect. When he runs about, he can encircle the con-
> tinent of Dzambuling three times in a single day. His body is
> free from sickness.[89]

In *Analysis of the Cause*, the precious horse appears quite differently:

> Just as the blue, black-headed horse of the king [possesses]
> cloud-power (*sprin-shugs*), so too Gautama [possesses] the far-
> famed (*grags-ldan*) pure abandonments (*yang-dag spong-ba*).[90]

In connection with the abandonments of the Buddha, there is a list of four points which are called the four pure abandonments (*yang-dag spong-ba*

bzhi, Skt. *catvāri samyakprahāṇa*), although only the first of them contains the verb "abandon." These are:

1. abandoning the unwholesome that has [already] arisen (*mi-dge-ba skyes-pa spong-ba*);
2. not allowing the unwholesome that has not [yet] arisen to arise (*mi-dge-ba ma-skyes-pa mi-bskyed-pa*);
3. causing the wholesome that has [already] arisen to increase (*dge-ba skyes-pa spel-ba*);
4. causing the wholesome that has not [yet] arisen to arise (*dge-ba ma-skyes-pa bskyed-pa*).

THE PRECIOUS GENERAL [OR HOUSEHOLDER]

དམག་དཔོན་རིན་པོ་ཆེ།

(dmag-dpon rin-po-che, Skt. *senāpatiratna)*

THE THREE FIGURES OF THE "MINISTER," "householder," and "general" are interrelated.[91] The minister is mainly allotted the task of making things happen, while the householder embodies or instantiates the basis—the people who revere the *cakravartin* and provide him with the means for his activities. The symbol of the general represents wrathful execution and victory over all obstacles.

The composition of the group of the Seven Jewels of Royal Power varies between different texts. When the general appears as an individual figure, the minister has automatically assumed the qualities of the householder together with his own, thus the quality of making things happen is seen rather in the sense of a peaceful administration. But if the householder appears as an individual figure instead of the general, then the minister has automatically taken on the properties of the general, and his making things happen is seen rather as a wrathful victory over all obstacles.

In *Mindful Establishment of the Excellent Dharma*, his role is explained as follows:

> The qualities of the precious householder are as follows: He possesses such wealth that gorges, abysses, hermitages and other disagreeable (*mi-mthun-pa*) [places] are completely filled— unasked—with diamonds, emeralds, precious *nīla* (*mthon-ka*) and *musālagalva* (*spug*), and other precious things. Moreover, even these precious substances are inexhaustible (*lta-zhig smos-kyang ci-dgos*), not to speak of gold and silver. The wealth of this precious

householder is very stable. He cheats and deceives no one, and does no harm to others. All the people are fond of him.[92]

It can be seen that the description of material wealth given here is meant to be transferred to the spiritual plane by the fact of its connection with the human quality of the householder, and most especially by the manner in which he intervenes to make unpleasant places into pleasant ones.

The direct link with the *cakravartin* is established in *Analysis of the Cause:*

> As the precious householder stands [in relation] to the *cakravartin,* so the four castes:[93] royal, priestly, middle caste, and lower caste, stand in relation to the Buddha; for the four castes have reverently provided the Thus Gone, the foe destroyer, the perfect buddha, with clothing, food, a sleeping place, a mat, medicines against sickness, and articles of use.[94]

This comparison between the householder in the kingdom of the *cakravartin* and the donors from the various castes who make offerings to the Buddha points to the importance of the householder as the provider, and, once again, to the equating of a *cakravartin* with a buddha.

HOW THE SEVEN JEWELS OF ROYAL POWER ARE USED

Having seen the explanations of the different symbols, now we will discuss their function. As signs bringing good fortune, they are used both according to their normal meaning as symbols of royal power, and according to their esoteric meaning in various rituals, such as in the offering of the mandala. Before considering the chants connected with presentation of the Seven Jewels, I shall first explain what is meant by a mandala in general, and the mandala offering in particular.

Mandalas and Mandala Offering

The mandala, in its oldest form, is simply a "space." This meaning was already established in the pre-Buddhist Indian tradition wherein a mandala was a square or round area, carefully marked off from its profane surroundings and specially purified, which was used, for instance, in Vedic sacrifices.[95]

In the Buddhist tantric practice of the Indo-Tibetan tradition, the mandala, as a sacred area, has been further developed to become the essential sign of non-conventional reality. It can be directly apprehended by the practitioner, but not in the familiar manner bounded by time and space. It

is the "other world," but it cannot be described with reference to the ordinary world in terms of "separate," "not separate," "included," or "excluded." The spiritual training methods of tantra aim to overcome the practitioners' conventional ideas that apply to the reality they know. For this purpose, the meaning of all the elements of their relational systems are explained anew to them from different planes, and made accessible to them. The practitioner learns to interpret the sum of his or her perceptions, no longer as a familiar, concrete environment, but rather to recognize in them the basic pattern—purified of all misleading concepts and individual chance factors—as one's own mandala. In Tibetan, the Sanskrit word *maṇḍala* is rendered with two different concepts according to the point of view. From one perspective, "center with surroundings" (*dkyil-'khor*) is used in regard to the meaning of the mandala as a meditation object, e.g., in the form of a design drawn on cloth (*ras-bris-kyi dkyil-'khor*), a mandala made of sand (*rdul-tshon-gyi dkyil-'khor*),[96] a mandala built up as a model (*blos-blangs-kyi dkyil-'khor*), or a mandala made solely by one's power of concentration (*bsam-gtan-gyi dkyil-'khor*). Alternatively, "essence" (*snying-po*) denotes the goal to be gained by meditation.

In outer practice, it is considered especially meritorious and effective for one's spiritual development to separate oneself symbolically from one's own mandala by offering it, as the most precious sacrifice to a deity or a lama. For this purpose, one can use a ritual mandala-offering set. This consists of a base, often with three or four concentric rings, and a finial. The material and fittings vary, in part according to the means of the owner. On the base of the set, grain, perhaps mixed with jewels or coins, is piled up according to special procedures, then made into a stable shape with the rings, and crowned with the finial. During the chanting and visualization, the practitioner keeps in mind that the attributes of secular royal power are, in their transformed form, spiritual qualities.

In the recitation that accompanies the mandala offering, the objects offered are expressly named; the Seven Jewels of Royal Power are so mentioned, along with many other constituents such as the golden ground, the surrounding wall, Mount Meru, the continents and sub-continents that form the universe, and so on.

Other Uses of the Seven Jewels of Royal Power

Apart from serving as elements of the mandala offering, the Seven Jewels are used in the form of sculptures and pictures as general offerings, as pictures on miniature cult figures, at the bottom edge of painted scrolls, painted on

walls and beams, as decorations on the rings of mandala-offering sets, or as butter ornaments on sacrificial cakes. They are presented to high ecclesiastical or secular dignitaries on special occasions such as their enthronement, the New Year, festivals of greeting or thanksgiving, or other important celebrations. They are also presented to the lama at the ceremony of "firmly remaining," in the "ritual of gratification" (*bskang-gso*), in the "rite for bringing about a fortunate destiny" (*g.yang-sgrub*), and at the conclusion of empowerment ceremonies.

The formal presentation of the Seven Jewels in these rituals is accompanied by special chants. These consist of highly abbreviated and coded formulae, whose full meaning cannot be understood without a complete explanation. Thus, for instance, the term "field" (*zhing*) stands for the mandala of the practitioner. The following chanting text is taken from the *Clear Mirror*:

> These Seven Jewels of a ruler of mankind, which have been prepared and spiritually transformed, I offer to all buddhas and bodhisattvas. Through this, may all living beings enjoy inexhaustible treasures.
> *Oṃ ma hā sapta ratna pū dza me gha āḥ hūṃ svāhā.*
>
> The wise fill this field completely with ‖:precious wheels:‖ and offer them daily out of their wisdom, so that their wish for realization may be fulfilled.
> *Oṃ cakra ratna pū dza me gha āḥ hūṃ svāhā...*[97]

In each of the following stanzas, the next item in the list of Seven Jewels is substituted into the text between the double lines (‖), followed by its respective offering mantra:

> ...precious jewels...
> *Oṃ ma ṇi ratna pū dza me gha āḥ hūṃ svāhā...*
>
> ...precious queens...
> *Oṃ strī ratna pū dza me gha āḥ hūṃ svāhā...*
>
> ...precious ministers...
> *Oṃ pu ru ṣa ratna pū dza me gha āḥ hūṃ svāhā...*

...precious elephants...

> *Oṃ ga ja ratna pū dza me gha āḥ hūṃ svāhā...*

...precious horses...

> *Oṃ a śva ratna pū dza me gha āḥ hūṃ svāhā...*

...precious generals...

> *Oṃ khaṅga ratna pū dza me gha āḥ hūṃ svāhā.*

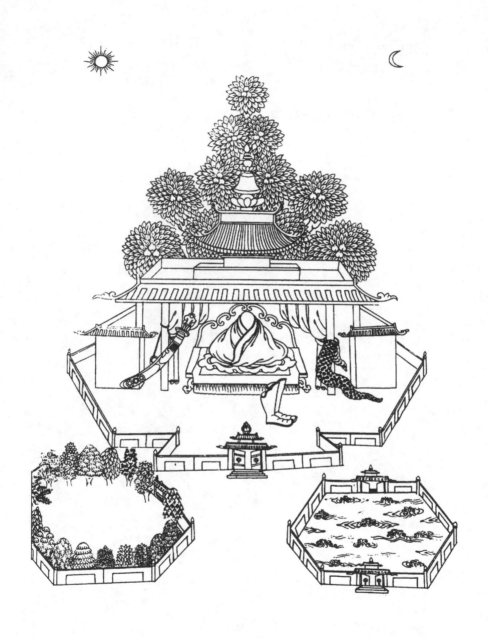

ཉེ་བའི་རིན་ཆེན་བདུན།

4

THE SEVEN SECONDARY JEWELS

ཉེ་བའི་རིན་ཆེན་བདུན།

(nye-ba'i rin-chen bdun, Skt. sapta upāratna)

THERE IS A FURTHER GROUP of seven signs associated with the *cakravartin*, to which the term "secondary" (*nye-ba*) is applied:

- the Sword (*ral-gri*, Skt. *khaḍga*)
- the Hide (*pags-pa*, Skt. *carman*)
- the Good House (*khang-bzang*, Skt. *harmya*)
- the Garment (*gos*, Skt. *cīvara*)
- the Garden (*tshal*, Skt. *vana*)
- the Seat (*mal-cha*, Skt. *śayana*)
- the Shoes (*lham*, Skt. *pulā*)

These are mentioned in the canonical text *Mindful Establishment of the Excellent Dharma*.[98]

The accoutrements of a world-ruler (*cakravartin*) consist not only of the previously described Seven Jewels of Royal Power, but also of the Seven Secondary Jewels. According to myth, the sphere of action of the *cakravartin* extends over the human realm and also a part of the sphere of the gods, namely, the desire realm and the form realm (see the Five Qualities of Enjoyment, p. 99). But whereas the Seven Jewels of Royal Power are distinguished by mysterious magical qualities, which largely remove them from direct human experience, the link between the *cakravartin* and the human realm is made clear through the Seven Secondary Jewels, which, although their description also includes magical elements, lie closer to the sphere of human imaginings.

Concerning this, *Mindful Establishment of the Excellent Dharma* says:

> The *cakravartin* uses the Seven Jewels of Royal Power and the
> Seven [Secondary] Jewels of the immediate environment in the
> four human spheres and the two kinds of divine surroundings
> (*mi'i gnas-bzhi dang lha'i rigs gnyis la nye-ba'i nye-bar spyod-pa*

yin-no). His thousand sons, bold heroes (*dpa'-zhing rtul-phod*), destroy all opponents (*pha-rol-gyi sde*). They prostrate themselves before the *cakravartin*. They will experience the blissful states which are brought about in appropriate measure by the path of the ten wholesome actions, which [consists] in the giving up of the unwholesome actions caused by negative mental states.[99]

The four human spheres are the four continents which, according to Buddhist cosmology, surround Mount Meru. The two divine realms are, as mentioned above, the desire realm (*'dod-khams*) and the form realm (*gzugs-khams*). In the third realm, the formless realm (*gzugs-med-khams*), the *cakravartin* cannot act, because this realm contains no physical forms. The thousand sons are those who follow or serve him. From the linguistic point of view, this corresponds to the "sons of the victor" (*rgyal-ba'i sras*), i.e., the bodhisattvas who follow the Buddha.

In the Buddhist interpretation of the *cakravartin* myth as found in canonical texts, the opponents are overcome "in accordance with Dharma," i.e., no harm is done to them; rather, they are led to the spiritual world of the *cakravartin* and thereby learn to gain happiness through wholesome actions.

In his *List of Terms that Occur in the "Basket" which Contains the Knowledge of Tantra*, Longdol Lama describes the Seven Secondary Jewels, mentioning other variations for comparison. For instance, in the mandala ritual of Tsukgu (*gTsug-dgu'i dkyil-chog*), the group consists of sword, hide, garden, bow and arrow, garment, shoes, and a brahmin's cord and needle. In the commentary on a kind of empowerment (*dbang-ṭik*), it consists of precious stones: ruby, sapphire, lapis lazuli, emerald, diamond, pearl, and coral.[100]

Mindful Establishment of the Excellent Dharma gives the following explanations for the different objects in the generally known list:

> If the inhabitants of some place wish to oppose the spirit or word of the king, the precious sword goes there, without striking anybody. Even though the precious sword does not strike anybody, yet all the inhabitants of the place show respect if they [merely] see it. The quality of this secondary jewel is this: it [works] well, inexhaustibly, and without pause, by causing all the inhabitants, although they are not pursued by the sword, to surrender of their own accord. That is the

quality of the secondary jewel of the sword.

What now is the quality of the secondary jewel of the hide? The precious hide comes from the sea. As soon as the dealers have obtained the precious hide from the sea, they bring it to the king. Its qualities are the following: It is the hide of a sea *nāga,* five *yojana* wide and ten *yojana* long; it does not become wet with rain, is not moved by the wind nor burnt by fire. In cold weather the hide gives warmth, and in hot weather it produces a pleasant coolness. Wherever the *cakravartin* goes with his entourage, the precious minister brings it with him. It performs all the housework for the king's people just the way they would do it, in all details. Ugly women are not to be seen: [through it] they become beautiful (literally, "white"). It also has the radiance of moon and sun.

Third, [there is] the king's precious seat: spacious, soft, and springy. Therefore, when one presses on it or releases it, it always yields (*btegs-na 'phar-ba dang mnan-na nem byed-pa*). If one thinks of [practicing] meditative absorption on it, the meditative absorption is fully developed [on it], and the mind is clarified. If one falls under the power of attachment, by sitting on the seat, one can at once be freed from attachment, without relapse. With hate and delusion [it is] similar. The seat as a secondary jewel is something like a place of meditative absorption. If the king sits on the precious seat and looks at the women, great joy arises in him on that account, although no attachment develops in his mind. This is the third item, the seat with its quality as secondary jewel.

Fourth, how many qualities of a secondary jewel does the garden possess? They are as follows: If the king wants [to practice] meditative absorption and goes there, then through the power of the garden and whatever wholesome deeds the king has done, the joys of the gardens of the god realms—flowers, fruit, birds, lotuses, ponds and pleasantly flowing streams, the daughters of the gods making music, smiling and charming—all come to this garden, and thereby the king possesses, like a king of the gods, the qualities of enjoyment of [the realm of] the gods. There, in the secondary jewel of the garden, he enjoys great pleasures together with the women. Whoever practices the yoga of wholesome deeds dwells in the garden of the fourth secondary jewel.

And what is the house of the *cakravartin* like? With how many qualities is it equipped? With the following: If anyone sleeps in the precious house of the *cakravartin* and in the night, at bedtime, wants to see the moon, then planets, stars, and falling stars come there to his house. They come there. If one merely sees its jewels, one is glad. Moreover, goddesses make divine music there. Freed of all sorrow, that person will sleep in bliss. In his sleep of great joy, he will experience pleasant dreams. During the cold periods, warm air rises, and in hot times, he will be fanned by cool air which rises pleasantly and gently. For two of the three phases of the night he will sleep, and in the third, free from sleep, he will get up and pass the time in a blissful way. This is the precious house of the *cakravartin*.

How many kinds of precious garments are there, and how many qualities do they possess? The following: They are finely woven, of excellent softness, and unstained by dirt. When one puts them on, cold, heat, hunger, thirst, weakness, exhaustion, and fatigue can no [longer] harm; fire and weapons can neither burn nor cut [one].

Further, the shoes of the *cakravartin* as a secondary jewel, what are they [like]? A yoga practitioner who dwells in contemplation of inner phenomena according to Dharma has understood by hearing, or has perceived with the divine eye, that when the *cakravartin* puts the precious shoes on his feet, they will not sink, just as if [he trod] on dry land. Likewise, he will not sink into water. If he wants to proceed slowly forward, he will go even a hundred *yojana* and not [feel] any tiredness in his body.[101]

In these images, we see all the fantasies that a person in ancient India might bring to mind which relate to wish-fulfillment and removal of daily worries. One often wonders involuntarily what kind of knowledge may lie concealed behind the descriptions of the fabulous technical possibilities available to the ancient kings. But of course we have no material on this.

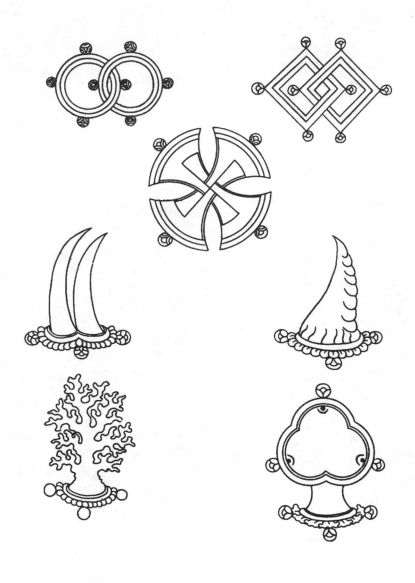

ནོར་བུ་ཆ་བདུན།

5

THE SEVEN GEMS
ནོར་བུ་ཆ་བདུན།
(nor-bu cha-bdun)

THE SEVEN GEMS IS THE NAME we give to a group of objects which have been taken over as individual symbols from Chinese art. There is, accordingly, no reliable Tibetan source from which we could derive detailed explanations concerning their description, designation, or meaning. Almost any interpretation appears to be possible and permissible. In order to give a sense of the variety, I have, in Table 2, drawn from four different sources in attempting to relate the ideas to their basic forms. To some degree, this is only possible by the principle of negative selection.

In my arrangement, I have—with one exception—followed the statements and the order of Longdol Lama's eighteenth-century work, *List of Terms that Occur in the "Basket" which Contains the Knowledge of Tantra*, since this is an original Tibetan text. The Seven Gems are listed as:

- the Unicorn (*bse-ru*)
- the Elephant's Tusks (*glang-chen mche-ba*)
- the Pair of King's Earrings (*rgyal-po'i rna-cha*)
- the Pair of Queen's Earrings (*btsun-mo'i rna-cha*)
- the Crossed Gems (*nor-bu bskor-cha*)
- the Three-Eyed Gem (*nor-bu mig-gsum-pa*)
- the Eight-Branched Coral (*byu-ru yan-lag brgyad-pa*)

Longdol Lama mentions "*dung-zho*" instead of "elephant's tusks" in the second place. This could be a matter of the exchange of an object for one of another group. The Eight Symbols of Good Fortune and the Eight Bringers of Good Fortune suggest themselves, if we assume that the conch shell (*dung*) and the yogurt (*zho*) have been combined in one symbol. On the basis of the forms usually depicted, and the agreement in the secondary literature, I have preferred to name the elephant's tusks here.

Description	Designation in			
	Dagyab[102]	Waddell[103]	Olschak/Wangyal[104]	Longdol Lama[105]
Group	—	Seven earrings	Included under Seven Jewels of Royal Power	—
1. Oval, pointed object	Unicorn's horn	*dmag-dpon rna-cha*	*bse-ru'i rva* (unicorn for horse)	*bse-ru*
2. Elephant's tusks	Elephant's tusks	*glang-po'i rna-cha*	*glang-chen mche-ba*	*dung-zho*
3. Earrings, round	King's earrings	*'khor-lo'i rna-cha*	*nor-bu*	*rgyal-po'i rna-cha*
4. Earrings, square	Queen's earrings	*btsun-mo'i rna-cha*	*rgyan* (minister's decoration)	*btsun-mo'i rna-cha*
5. Longish, crossed objects	Measuring unit	*blon-po'i rna-cha*	*dmag-dpon* (general's sword)	*nor-bu bskor-cha*
6. Triple Jewel	Three-eyed jewel	*rta-mchog rna-cha*	*khyi-sna* (for wheel)	*nor-bu mig-gsum*
7. Coral branch	Coral with branches	*nor-bu'i rna-cha*	*rgyal-mo lag* (for queen)	*byu-ru yan-lag brgyad-pa*

Table 2

If we ask by what route these symbols reached Tibet, one possible answer is that they were used as ornaments on silk brocade. The Tibetans are extremely fond of rich silk brocades, and have imported them for centuries. The best quality came from Russia, the second-best, from China, and Indian materials were somewhat less valued. On the Chinese brocades, certain figures constantly recurred, and accordingly, even without detailed information, they could have been interpreted as symbols of good fortune and allotted to the group of Seven Gems.

The Seven Gems are employed as ornaments on paths trodden by high spiritual and temporal dignitaries, they are depicted as offerings on painted scrolls and miniature cult pictures, on thrones, tents, tables, beds, and carpets, as well as on vessels for daily or religious use. They also serve as decorations on walls and beams, on currency notes, and on sacrificial cakes.

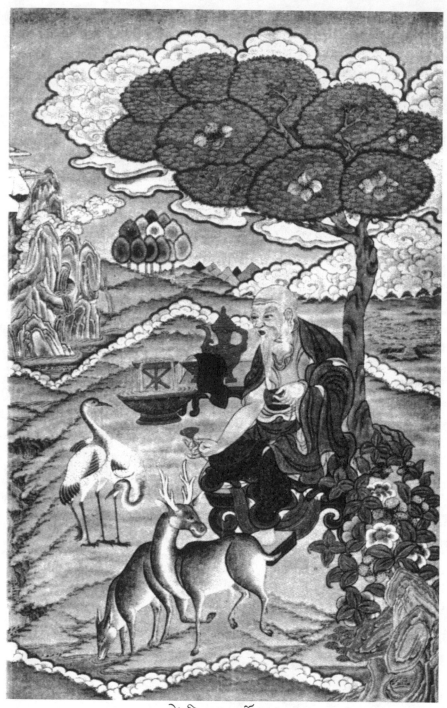

ཚེ་རིང་དྲུག་སྐོར།

6

THE SIX SIGNS OF LONG LIFE

ཚེ་རིང་དྲུག་སྐོར

(tshe-ring drug-skor)

THESE SIX SIGNS ARE A COLLECTION of symbols which separately, and especially together, represent long life:

- the Rock of Long Life (*brag tshe-ring*)
- the Water of Long Life (*chu tshe-ring*)
- the Tree of Long Life (*shing tshe-ring*)
- the Man with Long Life (*mi tshe-ring*)
- the Birds of Long Life (*bya tshe-ring*)
- the Antelope of Long Life (*ri-dvags tshe-ring*)

Unlike most of the foregoing groups of symbols, the Six Signs of Long Life are only to be seen in pictures. There are no offering rituals or chanting texts in connection with them. In illustrations, they are nearly always combined in a fixed composition, as in the scene shown here. The old man holds in his hands two small cymbals (*ting-shag*). Before him in a basin is a stand, on which there is a plate with water. Beside this is a dish with little sacrificial balls (*gtor-ril*), covered with a red silk cloth, and a pot filled with sacrificial water. This indicates that the old man is in the act of making a water offering (*chab-gtor*).

The water offering is one of the most common offering rituals, and is chiefly remarkable for being offered not only to the Three Jewels, in one or another form, since it is normally directed at a wider circle of recipients, arranged in four categories:

1. The "higher guests" (*yar-mgron*): lama (*bla-ma*), meditational deities (*yi-dam*), the Three Jewels (*dkon-mchog gsum*), protectors of religion (*chos-srung*), ḍākas and ḍākinīs (*dpa'-bo and mkha'-'gro*), gods and humans who have accomplished the word of truth (*lha-mi bden-tshig grub-pa*), gods of wealth (*nor-lha*), the gods born together with [the

offerer] (*lhan-cig skyes-pa'i lha*), and the gods who protect [the offerer] (*'tsho-ba'i lha* and *srung-zhin skyob-pa'i lha*).

2. The "middle guests" (*bar-mgron*): earth gods (*sa-lha*), local gods (*yul-lha*), mountain gods and their ilk (*gzhi-bdag sogs*), yakṣas (*gnod-sbyin*), a species of plundering yakṣinīs (*'phrog-ma*), powerful non-human beings (*mi-min mthu-chen*), various demons (*bsgegs* and *gdon*: see p. 000), and living beings in general (*'gro-ba*).

3. The "lower guests" (*mar-mgron*): hungry ghosts or pretas (*yi-dvags*), beings to whom [the offerer] owes something for which they wait with attachment for the return-gift (*lan-chags*), those that are waiting for meat or are parasitic on the body of the offerer (*sha-'khon*), and those who, in general, are waiting with attachment for the repayment of a debt owed by the offerer (*bu-lon chags-pa*), together with beings from the *bardo*—the intermediate state between death and rebirth.

4. The final category consists of those hungry ghosts who are hoping to get the leftovers of the offering (*lhag-ba re-ba'i yi-dvags*).[106]

The object of this observance is the practice of giving, and above all, the repaying of karmic "debts" owed to other beings. It can be termed a process of purification.

The Sixth Paṇchen Rinpoche, while in China, wrote the following lines in praise of these symbols of long life:

> Because formerly this realm of Greater China was blessed by the victors (*rgyal-ba*, Skt. *jina*) and their sons and daughters (*sras*, i.e., *bodhisattvas*) of the three times, the indestructible rocky mountain of vajra-nature, which possesses the seven qualities of changelessness, indestructibility, [and so on,] was produced. By the tree of long life, bowed down with fruits having the eight excellent flavors, which has grown out of the liquid (water) of the stream of the nectar of immortality that continually falls down from that (rock), the great seer (*ṛṣi*) with long life and

radiant fame dwells in a state of joy, in whom can be seen the meditative absorption in the wisdom of bliss (*bde-ba*), clarity (*gsal-pa*), and freedom from disturbing conceptions (*mi-rtog-pa*), owing to the penetrating power of the splendor and blessing (*gzhi-byin-stobs*) of Amitāyus (*Tshe-snang-dpag-med or Tshe-dpag-med*) into his heart. The antelopes that are eating the little sacrificial balls of the great seer have attained to a great age. The birds (*gnyis-skyes,* literally, "twice-born") became immortal because they enjoyed the advantage of drinking the nectar of the fruits of the tree.

At the place where the excellent and wholesome features exist that [I] have thus praised as the Six Signs of Long Life, the following will be automatically accomplished according to the word of truth (*bden-tshig*) of the seer: May all existing signs of misfortune and decline, and especially all dangers of untimely death, be overcome! May happiness, wealth, power, life, merit, and necessary utensils be increased!

These verses of praise for the excellent qualities of the six domains of long life, which is called "Robbing the Senses through [the mere] Sight [of this text]," was composed by me, the Buddhist monk (*Śākya'i dge-slong*), Losang Thupten Chökyi Nyima, in the land of Greater China.[107]

The poetic term "twice-born" is often used in referring to birds. When the egg is laid, that is the "first birth"; the hatching is considered the "second birth."

This encomium clearly illustrates, in exemplary fashion, how symbols were created and used in Tibetan culture and thought: the beneficent effects of intensive Buddhist practice are given concrete expression in the form of a mountain landscape inhabited by human beings and animals. If we call to mind such an exceptionally pure, power-filled region, or if we invoke it symbolically, that is *tendrel* (see pp. xvi–xvii). We are then able to share in its life-lengthening energy, which is fed from spiritual realization. Of course, it is a general, simple belief among Tibetans that these six signs are good for a long life, though scarcely anyone could give a reason for it.

The Six Signs are especially favored as symbolic of long life. They are often painted on the walls inside houses or in the inner courtyard, generally directly beside the door. They are also carved on thrones, tables, and beds, on vessels, saucers, and such, and reproduced on currency notes and, occasionally, as carpet patterns.

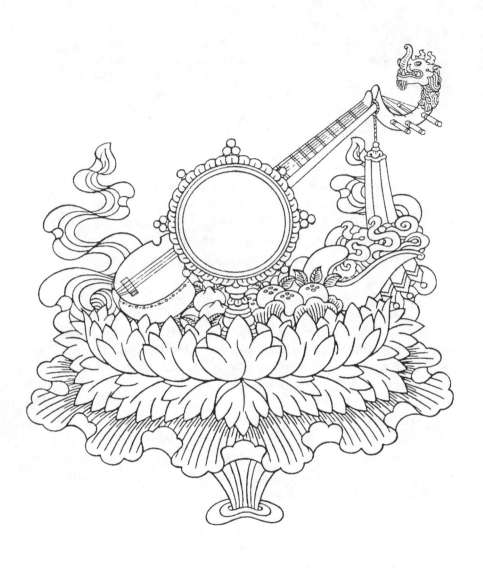

འདོད་ཡོན་སྒྲ་ཡ།

7

THE FIVE QUALITIES OF ENJOYMENT

འདོད་ཡོན་སྣ་ལྔ།

('dod-yon sna-lnga, Skt. pañcakāmaguṇā)

THE FIVE QUALITIES OF ENJOYMENT, of Desire or Craving, are symbols of the five groups of characteristics which, in contact with our sense organs, can produce the arising of greed (grasping at pleasure): visual form, sound, smell, taste, and tactile quality.[108] The corresponding symbols are:

- the Mirror (*me-long,* Skt. *ādarśa*)
- the Lute (*pi-wang,* Skt. *vīṇā*)
- the Incense Vessel (*spos-snod*)
- the Fruit (*shing-tog,* Skt. *phala*)
- the Silk (*dar,* Skt. *netra*)

They are described in canonical texts,[109] and to this day are used as ritual offerings, the giving of which is associated with certain recitations.[110] To appreciate their importance for the practitioner, we must understand the role that the concept of "greed" plays in the context of Buddhist explanations.

According to Western linguistic usage, "greed" implies an egocentric attitude of ruthless grasping at objects, the possession of which promises satisfaction. In Buddhism, this term is used in a considerably wider sense, not only for the grasping at objects, but also for the clinging to concepts about oneself and the whole environment. Accordingly, greed takes a particular place among the three "mental poisons" of greed, hatred, and delusion, which—according to the Buddhist teaching—are the causes of suffering. Without the obstinate clinging to the illusion of a concrete ego, hatred and folly would be inconceivable. Accordingly, it is also said that, of all the defilements or false attitudes that have to be gradually relinquished on the way to buddhahood, the latent tendencies (*bag-chags,* Skt. *vāsanā*) associated with attachment are those which the practitioner succeeds in abandoning only at the very last, immediately before reaching the goal.

THE THREE REALMS OF EXISTENCE

The considerable importance which Buddhism attaches to the effect of greed is reflected in the doctrine of the three realms and the terminology associated with them. The Tibetan term *'dod-yon* ("characteristic/quality of greed") is an abbreviation of *'dod-pa'i yon-tan*, which again is derived from *'dod-khams-kyi yon-tan* or *'dod-pa'i khams-kyi yon-tan* ("characteristic/quality of the realm of enjoyment"). The three realms, i.e., the (sense-)desire realm, the form realm, and the formless realm, represent another description of the possible forms of existence in samsara, which correspond as follows to the better-known sixfold division of samsaric places of rebirth:

Desire realm:
(*'dod-pa'i khams*, Skt. *kāmadhātu*) ←——

- realm of hell beings (*dmyal-ba*, Skt. *narak*)
- realm of hungry ghosts (*yi-dvags*, Skt. *pretā*)
- realm of animals (*dud-'gro*, Skt. *tiryañca*)
- realm of human beings (*mi*, Skt. *manusya*)
- realm of demigods (*lha-ma-yin*, Skt. *asura*)
- (portion of) realm of gods (*lha*, Skt. *deva*)

Form realm:
(*gzugs-khams*, Skt. *rūpadhātu*) ←——
- (portion of) realm of gods (*lha*, Skt. *deva*)

Formless realm:
(*gzugs-med-khams*, Skt. *arūpadhātu*) ←——
- (portion of) realm of gods (*lha*, Skt. *deva*)

According to this cosmology, human beings belong to the desire realm, as do all beings in the other realms of rebirth, with the exception of certain gods. Gods may be born into any of the three realms, all of which, however, belong to samsara. The formless realm is not to be confused with buddhahood or nirvana. Therefore, rebirth into any one of these realms, despite all its attractions, is not something a Buddhist should wish for. In detail, the three realms are described as follows:

1. Desire realm: The beings in this realm experience a material world in which consciousness is subject mainly to external (sensory) stimulation. This realm, in which "grosser" existences are established, is marked by grasping after things and experiences.

2. Form realm: Here, the beings experience a kind of physical presence within a physical environment, but on a more subtle level. Owing to their deeper knowledge of the relationship between a person's consciousness and

his or her outward surroundings, the beings in this realm have a greater range of possibilities with respect to the forms they can create. Being fascinated by the use and enjoyment of these possibilities, they take very little interest in the grosser states of existence.

3. Formless realm: The beings in this realm, or mode of existence, no longer assume physical form. The Tibetan expression for this type of purely mental presence or "existence in abstraction" is "mental body" (*yid-lus*), but the word "body" is not taken so concretely as in Western languages.

Within these three realms there are many stages of progressive refinement. However, this must not be interpreted as an automatic ascent. In Buddhist theory, there is no such thing as a fixed order of births eventually leading, at some future time, to rebirth in the formless realm. The differences between the various realms do not reflect "stages of existence," but only the differences in perception of the beings involved in those realms and the differences in their ability to concentrate on the subtle plane.

Thus, what binds sentient beings to their painful existence is greed, which ultimately depends on fundamental ignorance. Accordingly, the practitioner strives intently to reach an understanding of the causes, occasions, and effects of greed. This presence of greed in the mind accounts for our persistent preoccupation with the external qualities of our material world, and, correspondingly, their influence on our minds.

In offering these "sense-able" qualities, symbolized by various objects, an outer and an inner level are likewise distinguished.

On the outer level, the offerings are always an expression of veneration towards the recipient, whether Buddha, meditational deity, and/or lama. For this reason, practitioners will choose (both physically and in their meditative visualization) especially beautiful, immaculate, and valuable objects to express symbolically their intention.

On the inner level, we remind ourselves during the preparation and the presentation that the five qualities are literally all that we possess, the extent of what is available to us. Quite irrespective of whatever idea we may have of what the world is like outside our immediate sphere of experience, our only contact with it is simply and solely through the door of perception of the five qualities. Everything else is deduction from them, and consequent concepts. If we have understood that, we have advanced a step further in

our practice towards the relativization of our thought patterns.

This relativization is often evoked and practiced by the tantric practitioner through seeing the world as a pure realm, with phenomena and processes as deities or pure beings. It is not the world itself, but one's way of viewing the world, that is transformed by making use of the relation between perception and creation. As an example, I have chosen an extract from the *rGyud-kyi rgyal-po chen-po dpal gsang-ba 'dus-pa'i rgya-cher 'grel-pa* (*Śrīguhyasamājamahātantrarājaṭīkā*), which cannot be understood at all except in this light. Since the present work is not primarily concerned with the treatment of tantric themes, I will abstain from a more extended commentary.

The practitioner imagines himself or herself as the essence of non-separation from wisdom and from the secret mandala. In so doing, one offers the Five Qualities of Enjoyment in connection with the three aspects of the sacrifice. These three aspects are the outer, the inner, and the secret. Regarding this, the exalted Jñānapāda (*Ye-shes-zhabs*) has explained fifteen kinds of the outer, fifteen kinds of the inner, and fifteen kinds of the secret aspect. A summary of the contents is here clearly presented...

As regards the outer aspect, the essence of the form of the mirror should be considered as Vairocana. The essence of the immaculate clarity should be considered as Kṣitigarbha (*Sa-yi-snying-po*). The essence of the arising of the reflection should be considered as the goddess Rūpavajradevī (*gZugs-rdo-rje-ma*). Thus the outer form is to be understood in three ways.

Next, the inner aspect is presented in three ways: Since Vairocana is form, the realizer regards the essence of the form of the eye [as a part] of one's own body as Vairocana. Likewise, the eyeball and its power of perception are regarded as the essence of Kṣitigarbha. And, similarly, the perception of the forms of the wisdom mandalas and the secret mandalas, with their profusion of gods with various body colors, symbolic hand gestures, etc., and their bright and shining rays of wisdom, as well as the beauty of the various kinds of adornment which [arise] through the power of perception of the eye, should be regarded—in their essence—as the goddess Rūpavajradevī. Thus the inner form is to be understood in three ways.

Further, as regards the secret aspect...[111]

I have omitted explanations of the secret aspect, both here and in the annexed table, because the plain text is unintelligible without lengthy explanations. Approaching the sexual symbolism of tantric commentaries, which outsiders only too frequently confuse with conventional sexuality, requires special preconditions and skills, as well as an expanded radius of perception.

In the passage here translated, the mirror is symbolic of the visually graspable form, whereas, in the Eight Bringers of Good Fortune, it was taken as a symbol of consciousness. The differing treatments of this object has incidentally shown once again that the relation between the viewer and the object viewed is closer than conventional modes of thought suppose. It is like two different pairs of spectacles, through which only one and the same reality is to be observed. One of the central aims of Buddhist theory is to point out again and again this non-separation between the perceiver and the perceived world.

I have confined myself here to the first of the Five Qualities of Enjoyment, just to give an example of this kind of explanation. Information about all five symbols is summarized in slightly abbreviated form in Table 3 (p. 104).

HOW THE FIVE QUALITIES OF ENJOYMENT ARE USED

The Five Qualities of Enjoyment, or Desire, are symbolically presented as offerings, either in the form of concrete objects, or represented on painted scrolls or miniature cult pictures. They are also found painted on walls and beams, as butter ornaments on sacrificial cakes, on currency notes, on vessels for religious or secular purposes, and on tables, bedsteads, and tents.

The symbolic offering in the ritual is accompanied by chants such as the following, which is taken from the *Clear Mirror*:

> Although the victor commands immaculate wealth, for the welfare of beings, I offer the Five Qualities of Enjoyment. May all beings thereby enjoy the inexhaustible treasure of merit!
> *Oṃ bajra samanta bha dra pū dza me gha āḥ hūṃ svāhā.*

> The blue lapis lazuli, the mighty king of precious things, and other forms of color and shape, having made them into *Rūpavajradevī* in triple fashion [outer, inner, and secret], I offer to the eyes of the lama-deity.
> *Oṃ rū pa pū dza me gha āḥ hūṃ svāhā.*

Aspect	Mirror	Lute	Incense vessel	Fruit	Silk
Nature of the Form	*Vairocana*	*Ratnasambhava*	*Amitābha*	*Amoghasiddhi*	*Akṣobhya*
Outer aspect:	Mirror	Lute	Objects of smell	All kinds of food	All kinds of human and divine clothing
Inner aspect:	Eyes	Ears	Nose	Mouth	Skin
Secret aspect:	—	—	—	—	—
Nature of the quality	*Kṣitigarbha*	*Vajrapāṇi*	*Ākāśagarbha*	*Avalokiteśvari*	*Sarvanīvaraṇaviṣ-kambhī*
Outer aspect:	Clarity	Playing the lute	Color of objects of smell	Taste	Various colors and forms of clothing
Inner aspect:	Power of vision	Power of hearing	Power of smelling	Power of tasting	Power of touching
Secret aspect:	—	—	—	—	—
Nature of the experience	*Rūpavajradevī*	*Śabdavajradevī*	*Gandhavajradevī*	*Rasavajradevī*	*Sparśavajradevī*
Outer aspect:	Reflection	Sound, audibility	Arising of scent from objects of smell	Various taste-experiences	Softness of clothing
Inner aspect:	Seeing the mandala	Hearing the sounds	Enjoying the smells	Enjoying the tastes	Pleasant sensations of touch
Secret aspect:	—	—	—	—	—

Table 3

The indescribable sounds produced by the assemblies of inani-mate elements and all other collections of sounds, having made them into *Śabdavajradevī* in triple fashion, I offer to the ears of the lama-deity.

Oṃ śapta pū dza me gha āḥ hūṃ svāhā.

All the scents that arise from the good combination of cam-phor, aloes, nutmeg, and other (pleasant-smelling substances), having made them into *Gandhavajradevī* in triple fashion, I offer to the nose of the lama-deity.

Oṃ gandhe pū dza me gha āḥ hūṃ svāhā.

The tastes of sweet, sour, bitter, hot, etc., of the ambrosial dish-es which strengthen the excellent body, having made them into *Rasavajradevī* in triple fashion, I offer to the tongue of the lama-deity.

Oṃ ra sa pū dza me gha āḥ hūṃ svāhā.

The wishing-garment, which grants happiness just by touching the body, and all other such tangible things, having made them into *Sparśavajradevī* in triple fashion, I offer to the body of the lama-deity.

Oṃ sparśa pū dza me gha āḥ hūṃ svāhā.[112]

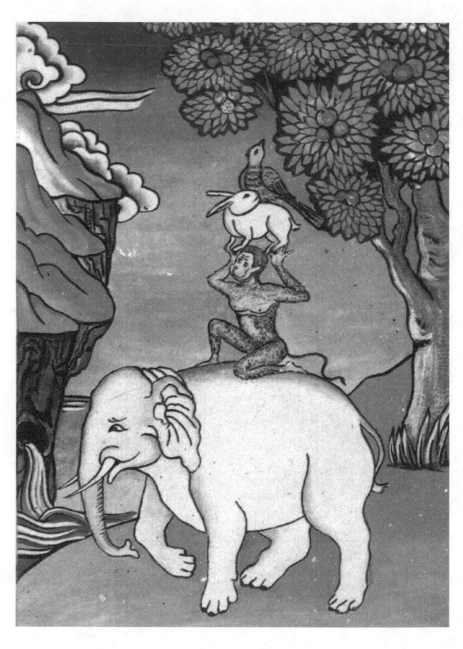

མཐུན་པོ་སྤུན་བཞི།

8

THE FOUR HARMONIOUS BROTHERS

མཐུན་པོ་སྤུན་བཞི།

(mthun-po spun-bzhi, Skt. catvāri anukulabhrātṛ)

THIS GROUP OF SYMBOLS CONSISTS of the following animals:

- the Partridge or Grouse *(gong-ma-sreg, Skt. kapiñjala)*
- the Hare *(ri-bong, Skt. śaśa)*
- the Monkey *(spre'u, Skt. kapi)*
- the Elephant *(glang-po-che, Skt. hastin)*

The fable of the Four Harmonious Brothers is told in the canonical text, the *Foundation of Discipline ('Dul-ba gzhi, Skt. Vinayavastu)*.[113] Buddha Śākyamuni is supposed to have told it to his disciples in order to impress on them the importance of mutual respect and the practice of the Buddhist virtues. The following short account comes from Panglung Rinpoche's German version of the narratives found in the *Mūlasarvāstivāda-vinaya*:

> Once there lived in the forest a partridge, a hare, a monkey, and an elephant, who were friends. With the aid of a tree, they established their respective ages, and accordingly, the younger animals respected the elder ones. They obeyed the law and lived a virtuous life. Soon, all the animals adopted their ways, and eventually the king of the country did likewise. On this account, peace and happiness prevailed in the land, and this was praised by Indra. I was the partridge, and Śāriputra, Maudgalyāyana, and Ānanda were the other animals.[114]

It is clearly a deeply rooted wish in various cultures to teach people the importance of unity, harmony, and collaboration as valuable factors for survival, and fables are often employed for this purpose. In the West, there is the somewhat similar tale of the Bremen Town Musicians, told by the Brothers Grimm. The tale of the Four Harmonious Brothers was no less beloved in ancient India, and remains so to this day in Tibet and Mongolia.[115]

In pictures, the animals are always shown as a pyramid with the partridge at the top, under him, the hare carried by the monkey, who is sitting on the elephant. Whether this pyramid represents the different generations, the social classes, or simply the cooperation of different types of individuals, in any case they are meant to show the viewer the benefits of cooperation for the general good.

This scene is often painted on temple doors. It is also found adorning tables and beds, and as a decoration for vessels, saucers, lids, and currency notes. Further, it adorns tent walls and is modeled in butter for offerings.

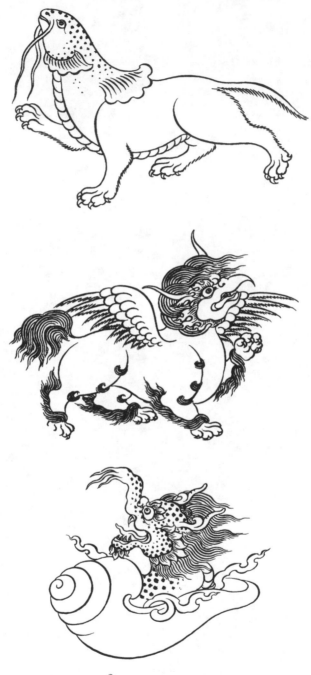

མེ་པ་གཞན་གསུམ་ཆུ་ལ།

THE THREE SYMBOLS OF VICTORY IN THE FIGHT AGAINST DISHARMONY

མི་མཐུན་གཡུལ་རྒྱལ།

(mi-mthun g.yul-rgyal)

THE SYMBOLS OF VICTORY in the Fight Against Disharmony, or Disagreement, are three mythical animals, each of which is composed of parts of two mutually hostile beasts:

- the Eight-Legged Lion *(seng-ge rkang-pa brgyad-pa)*
- the Fur-Bearing Fish *(nya spu rgyas-pa)*
- the Makara Crocodile *(chu-srin ma-ka-ra)*

According to myth, they are each supposed to have sprung from the union of two rival animals. I give a short description of each following the text *Grub-chen lū-i-pa'i lugs-kyi dpal 'khor-lo sdom-pa'i bskyed-rim he-ru-ka'i zhal-lung*:

> The eight-legged lion is the son of a union of a *garuḍa*[116] and a lion. He has the overall body of a lion, [but] with two wings. He has claws at the knees...
>
> The fur-bearing fish is the son of a fish and an otter. He has the overall body of a fish, [but] with an otter's fur...
>
> The *makara* crocodile is the son of a snail and a crocodile. His whole body is firm like a snail shell. He is [also] generally regarded as the son of a union between crocodile, dragon, and snake. His tail forms entwined patterns *(pa-tra)*.[117]

In artistic representations, the lion, contrary to the text, always has the head of a *garuḍa*. The claws at his knees are very seldom depicted.

The fish is nearly always shown with the body of an otter, but with a fish's head and flippers.

Although the Tibetan term *chu-srin* is always translated "crocodile" in the secondary literature, in Sino-Tibetan literature it is more of a fabulous monster than a crocodile. Accordingly, when depicted in combination with

the snail shell, it is shown having a head with a mane, and its shape is only vaguely reminiscent of a normal crocodile.

Among the signs of victory (see p. 29), a sign with applied animals was mentioned, which in normal Tibetan usage is called a banner (*ba-dan*), but is described in classical Tibetan literature as a sign of victory (*rgyal-mtshan*). The animal applications always take the form of the three pairs of animals described here. The only explanation I can find for the use of these animal symbols to represent a strong *tendrel* for the spreading of harmony is that they depict combinations of mutually hostile animals. The victory signs thus adorned are called "signs of victory in the fight against disharmony" (*mi-mthun g.yul-las rgyal-ba'i rgyal-mtshan*).

These symbolic beasts are also shown on painted scrolls, miniature cult pictures, painted on walls and beams, on tents and marquees, tables, beds, and vessels for religious and everyday use, as butter ornaments for sacrificial cakes, and depicted on thrones.

CONCLUSION

I HAVE COME TO THE END of my descriptions and explanations of the nine groups of symbols. I have based myself, as far as possible, on the original Tibetan literature, supplementing the material found there with explanations of the use of these symbols in Tibetan Buddhist culture. Even though I have tried to consider each symbol from various points of view, I am very well aware that I have not been able to convey more than a few single threads of a once dense network. Still, even this short sketch may form the starting point for further investigations. There is much that we can no longer describe, because the sources of information have failed or been destroyed, so that it is irrevocably lost. But even so, today we still have the chance to form an authentic connection to some of the traditional forms of expression of a more profound knowledge, provided we have the courage to approach the theme from different levels. The symbols can offer us points of support in this—helping the Buddhist in his or her practice, and the interested inquirer to a broader understanding, which may also be of benefit.

NOTES

1. This is a Tibetan-Sanskrit terminological dictionary. The edition used here is the two-volume Japanese edition.

2. The Tibetan terms are: *dvangs-ba'i dad-pa, yid-ches-kyi dad-pa,* and *mngon-'dod-kyi dad-pa.*

CHAPTER ONE: THE EIGHT SYMBOLS OF GOOD FORTUNE

3. Stutley, *A Dictionary of Hinduism,* p. 22; Moeller, *Symbolik des Hinduismus und des Jainismus,* p. 104, fig. 85, p. 132, fig. 110 and p. 134, fig. 112; Liebert, *Iconographic Dictionary,* p. 26.

4. *'Phags-pa bkra-shis brtsegs-pa zhes-bya-ba theg-pa chen-po'i mdo (Āryamaṅgalakūṭanāmamahāyānasūtra),* p. 531a, 7.

5. Tsong-kha-pa, *rJe thams-cad mkhyen-pa tsong-kha-pa chen-po'i bka'-'bum thor-bu,* p. 223a, 5.

6. 'Brum-ston rGyal-ba'i-'byung-gnas, *Jo-bo-rje dpal-ldan a-ti-sha'i rnam-thar rgyas-pa yongs-grags,* p. 9a, 4.

7. Dagyab, *Tibetan Religious Art,* part II, plate 20.

8. Liebert, *Iconographic Dictionary,* p. 176.

9. Moeller, *Symbolik des Hinduismus und des Jainismus,* p. 12.

10. Kirfel, *Symbolik des Hinduismus und des Jainismus,* p. 122, 155; Moeller, *Symbolik des Hinduismus und des Jainismus,* p. 124.

11. Stutley, *A Dictionary of Hinduism,* p. 136.

12. dGe-'dun-rgya-mtsho, *rGyal-po chen-po rnam-thos-sras-la mchod-gtor 'bul-ba'i rim-pa dngos-grub-kyi bang-mdzod,* p. 3a,1.

13. Liebert, *Iconographic Dictionary,* p. 202, under "padma."

14. Stutley, *A Dictionary of Hinduism,* p. 266.

15. Yongs-'dzin Khri-zur Byang-chub-chos-'phel, *dPal-ldan stod-rgyud*

lugs-kyi rab-gnas dge-legs char-'bebs-kyi ngag-'don phyogs-bsgrigs gsal-byed me-long, p. 26b, 5.

16. Liebert, *Iconographic Dictionary,* p. 186. Rigzin, *Tibetan-English Dictionary of Buddhist Terminology,* p. 9, reports that a *nāga (klu)* is "a kind of being regarded as belonging to the animal class; believed to abide in subterranean realms, having control over rain, ponds, rivers and soil productivity; some are Dharma protectors, but they can bring retribution if they are disturbed; often in Buddhist art and in written accounts, they are portrayed as being half human and half snake."

17. Moeller, *Symbolik des Hinduismus und des Jainismus,* p. 13.

18. Kirfel, *Symbolik des Hinduismus und des Jainismus,* p. 154.

19. Tsong-kha-pa, *rJe thams-cad mkhyen-pa tsong-kha-pa chen-po'i bka'-'bum thor-bu,* p. 223a, 4.

20. dGe-'dun-rgya-mtsho, *rGyal-po chen-po rnam-thos-sras-la mchod-gtor 'bul-ba'i rim-pa dngos-grub-kyi bang-mdzod,* p. 3b, 5.

21. Liebert, *Iconographic Dictionary,* p. 51, under *"cakra"* and p. 53, under *"cakravartin."*

22. Gung-thang dKon-mchog-bstan-pa'i-sgron-me, *Khro-bcu'i bsrung-'khor rdo-rje'i go-khrab ngar-ma'i rno-mtshon-dang bcas-pa,* p. 3a, 4.

23. For the original terms in Tibetan, refer to the glossary under *training, three kinds of.*

24. Khri-byang Rin-po-che, *dGa'-ldan khri-chen byang-chub chos-phel-gyi skye-gral-du rlom-pa'i gyi-na-pa zhig-gis rang-gi ngang-tshul ma-bcos lhug-par bkod-pa 'khrul-snang sgyu-ma'i zlos-gar,* p. 210b, 3.

25. *'Phags-pa bkra-shis brtsegs-pa zhes-bya-ba theg-pa chen-po'i mdo (Āryamaṅgalakūṭanāmamahāyānasūtra),* p. 531a, 7, reads as follows:

> / na-mo dbu-la bkra-shis gdugs-ltar-skyob /
> / spyan-la bkra-shis rin-chen gser-gyi-nya /
> / mgul-la bkra-shis rin-chen bum-pa-'khyil /
> / ljags-la bkra-shis padmo lo-'dab-rgyas /
> / gsung-la bkra-shis chos-dung g.yas-su-'khyil /
> / thugs-la bkra-shis dpal-gyi be'u-gsal /
> / phyag-la bkra-shis yon-tan nor-bu-mchog /
> / sku-la bkra-shis mi-nub rgyal-mtshan-mchog /
> / zhabs-la bkra-shis phrin-las 'khor-lo-lnga [mnga'] /
> / bkra-shis rdzas-brgyad dngos-grub dam-pa'i-mchog /

/ rdzas-mchog brgyad-kyi bkra-shis gang-yin-pa /
/ deng-'dir bdag-cag rnams-la bkra-shis phob
/ bkra-shis des-kyang rtag-tu bde-legs-shog /

In the ninth line, *lnga* must be a misprint. The correct reading, as translated, is *mnga'.*

26. These four, in Tibetan, are: *chos, nor, 'dod-pa,* and *thar-pa.*

27. *dGa'-ldan dar-rgyas gling-gi chos-spyod-las mnga'-'bul-skor bzhugs-so.* The Tibetan original reads:

gdugs-la
/ rgyal-ba'i dbu-las skyob-byed grib-bsil-mchog /
/ gdul-bya'i dad-gsum mthus-brgyas legs-brten-rdzas /
/ thugs-rje sham-bus kun-nas bskor-ba can /
/ bkra-shis gdugs-kyis dge-legs 'bar-gyur-cig /

gser-nyar
/ kun-mkhyen spyan-gyi rgya-mtsho las-thon-zhing /
/ thabs-shes zung-jug gzhan-phan chab-la-brten /
/ don-gnyis gser-mig 'phrin-las gshog-rlabs-che /
/ bkra-shis gser-nyas dge-legs 'bar-gyur-cig /

gter-bum
/ kun-mkhyen mgul-las 'dzad-med nam-mkha'i-mdzod /
/ 'dod-khams 'dab-ma gzugs-khams lto-bcud-ldan /
/ gzugs-med stong-cha chas-brgyan srid-zhi'i-dpal /
/ bkra-shis bum-pas dge-legs 'bar-gyur-cig /

padma-la
/ mi-yi seng-ge'i ljags-las dri-bral-rdzas /
/ 'khor-skyong 'dam-gyis ma-gos kha-dog-mdzes /
/ rnam-grol dri-la skal-ldan bun-bas-rtsen /
/ bkra-shis pad-mas dge-legs 'bar-gyur-cig /

dung-g.yas-'khyil
/ 'dren-mchog tshems-las dri-med rang-byung-rdzas /
/ rnam-dag lam-rim ri-mo g.yas-su-'khyil /
/ theg-chen chos-sgras 'brel-tshad dge-la-sbyor /
/ bkra-shis dung-gis dge-legs 'bar-gyur-cig /

dpal be'ur
/ rgyal-kun thugs-gsang mtshon-byed za-ma-tog /
/ g.yung-drung lu-gu rgyud-kyi dra-ba-can /

/ 'dzad-med gter-gyi ngo-bo khyad-'phags-nor /
/ bkra-shis dpal-be'us dge-legs 'bar-gyur-cig /

rgyal-mtshan la
/ rgyal-ba'i sku-mchog phyogs-las rnam-rgyal-rdzas /
/ srid-las rnam-grol rin-chen tog-dang-ni /
/ zhi-la mi-gnas sna-tshogs dar-sham-can /
/ bkra-shis rgyal-mtshan dge-legs 'bar-gyur-cig /

'khor-lo la
/ tshogs-gnyis btso-ma'i gser-sbyans rnam-dag-las /
/ legs-grub rab-'byams 'phrin-las rtsibs-stong-ldan /
/ chos-nor 'dod-thar sde-bzhi'i 'byung-gnas-che /
/ bkra-shis 'khor-lo dge-legs'bar-gyur-cig /

28. Kirfel, *Symbolik des Buddhismus*, p. 22.

29. Yongs-'dzin Khri-zur Byang-chub-chos-'phel, *dPal-ldan stod-rgyud lugs-kyi rab-gnas dge-legs char-'bebs-kyi ngag-'don phyogs-bsgrigs gsal-byed me-long*, fol. 26b. The Tibetan reads as follows:

/ ji-ltar sngon-gyi sangs-rgyas la /
/ gdugs-dkar gser-gyi yu-ba can /
/ phul-ba de-bzhin bdag-'bul gyi /
/ ci-bde bar-ni bzhes-su gsol /

/ ji-ltar sngon-gyi sangs-rgyas la /
/ na-bza' gser-gyi nya-ris can /
/ phul-ba de-bzhin bdag-'bul gyi /
/ ci-bde bar-ni bzhes-su gsol /

/ ji-ltar sngon-gyi sangs-rgyas la /
/ re-ba thams-cad rdzogs-mdzad pa'i /
/ bum-pa bzang-po phul-ba ltar /
/ de-bzhin bdag-gis dbul-bar bgyi /

/ ji-ltar sngon-gyi sangs-rgyas la /
/ 'dam-gyi skyon-gyis ma-gos pa'i /
/ padma dkar-po phul-ba ltar /
/ de-bzhin bdag-gis dbul-bar bgyi /

/ ji-ltar sngon-gyi sangs-rgyas la /
/ snyan-pa phyogs-bcur sgrog-pa yi /
/ 'bud dung g.yas-'khyil phul-ba ltar /

/ de-bzhin bdag-gis dbul-bar bgyi /

/ ji-ltar sngon-gyi sangs-rgyas la /
/ dpal-gyi be'u g.yung-drung 'khyil /
/ dge-ba'i don-du mnga'-ba ltar /
/ de-bzhin bdag-gis dbul-bar bgyi /

/ ji-ltar sngon-gyi sangs-rgyas la /
/ nyon-mongs bdud-las rgyal-ba yi /
/ chos-kyi rgyal-mtshan phul-ba ltar /
/ de-bzhin bdag-gis dbul-bar bgyi /

/ ji-ltar sngon-gyi sangs-rgyas la /
/ gser-gyi 'khor-lo mu-khyud can /
/ tshangs-pa chen-pos phul-ba ltar /
/ de-bzhin bdag-gis dbul-bar bgyi /

30. Pha-bong-kha-pa Byams-pa-bstan-'dzin-'phrin-las-rgya-mtsho, *bLa-ma mchod-pa'i cho-ga-la brten-nas zhing-dam-par mkha'-'gro'i brtan-bzhugs 'bul-tshul lhan-thabs-su bkod-pa bzhugs-so*, fol. 7b. The Tibetan reads:

/ 'khor-lo rgyal-mtshan gdugs-dang dpal-be'u /
/ padma bum-bzang gser-nya dung-g.yas-'khyil /
/ mchog-tu bkra-shis mtshan-pa'i rtags-brgyad-po /
/ phyogs-dus kun-tu dge-legs 'phel-phyir-'bul /

31. 'Jam-dbyangs bLo-gter-dbang-po, *mNyam-med jo-bo chen-po-nas brgyud-pa'i rdo-rje mi-'khrugs-pa mchog-gi sprul-sku lha-dgu'i dbang-tho las-sgrib rnam-sbyong zhes-bya-ba*. In *rGyud-sde-kun-btus*, II, ff. 489–492. Quotation from ff. 491–492:

/ bkra-shis gang-zhig mchod-pa'i lha-mo-ni /
/ ... phyag-na dpal-gyi be'u rab-'bar-ba /
/ bsnams-nas rgyal-ba'i thugs-la mchod-pa ltar /
/ thugs-la dpal-be'u'i bkra-shis thob-par-shog /...
/ ... phyag-na gser-gyi 'khor-lo 'od-'bar-ba /
/ bsnams-nas rgyal-ba'i zhabs-la mchod-pa ltar /
/ zhabs-la 'khor-lo'i bkra-shis thob-par shog /...
/ phyag-na padma dmar-po 'dab-brgyad-pa /
/ bsnams-nas rgyal-ba'i ljags-la mchod-par-ltar /
/ ljags-la padma'i bkra-shis ...
/ ... phyag-na rin-chen rgyal-mtshan rab-mdzes-pa /

/ bsnams-nas rgyal-ba'i sku-la mchod-pa-ltar /
/ sku-la rgyal-mtshan …
/ phyag-na gdugs-bzang gser-gyi yu-ba-can /
/ bsnams-nas rgyal-ba'i dbu-la …
/ dbu-la gdugs-kyi …
/ … phyag-na rin-chen bum-pa rab-mdzes-pa /
/ bsnams-nas rgyal-ba'i mgul-la …

See also 'Jam-dbyangs bLo-gter-dbang-po, *bCom-ldan-'das rdo-rje mi-'khrugs-pa'i dkyil-'khor-du slob-ma dbang-bskur-ba'i cho-ga gzhan-phan zla-snang.* In *rGyud-sde-kun-btus,* II, ff. 464–488. Quotation from fol. 482:

> *… 'dab-ma brgyad-la shar-du padma-can dkar-mo g.yas dpal padma 'dzin-pa / lhor 'od-ldan-ma dmar-mo g.yas padma 'dzin-pa / nub-tu mdangs-ldan ma sngon-mo g.yas gdugs 'dzin-pa / byang-du dri-med-ma ljang-khu g.yas dung 'dzin-pa / mer 'jigs-byed-ma dkar-mo g.yas 'khor-lo 'dzin-pa / srin-por rnal-'byor-ma sngon-mo g.yas rgyal-mtshan 'dzin-pa / rlung-du dkar-sham-ma dmar-skya g.yas bum-pa 'dzin-pa / dbang-ldan-du yid-gzhung-ma ljang-khu g.yas gser-nya 'dzin-pa / …*

32. Khri-byang Rin-po-che, *dGa'-ldan khri-chen byang-chub chos-phel-gyi skye-gral-du rlom-pa'i gyi-na-pa zhig-gis rang-gi ngang-tshul ma-bcos lhug-par bkod-pa 'khrul-snang sgyu-ma'i zlos-gar,*
fol. 107a:

> *… yongs-'dzin stag-brag rdo-rje-'chang srid-skyong-du mnga'-gsol gnang-ba-bzhin… bkra-shis rtags-rdzas-sogs 'bu-ba…*

fol. 176b:

> *… g.yul-rgyal lhun-po'i-rtse'i rdzong-chen-du gong-sa-mchog zhabs-'khod-thog der bod-kyi gnas-skabs-kyi rgyal-sa mdzad-bzhed-kyis tshom-chen-du ston-'khor tshang-'dzoms-kyis rten-'brel mdzad-sgo rob-bsdus-shig mdzad-song-ba'i bzhugs-gral-du bcar-zhin / yongs-'dzin gling rin-po-che nas maṇḍal bshad-'bul-dang / phran-*

*nas bkra-shis rdzas-rtags sogs tshigs-bcad-dang 'brel
'degs-'bul-zhus...*

The autobiography of Khri-byang Rin-po-che, *Magical Play of
Illusion,* translated by Sharpa Tulku and edited by Jonathan Landaw,
is forthcoming from Wisdom Publications.

CHAPTER TWO: THE EIGHT BRINGERS OF GOOD FORTUNE

33. Ratnaśila, *rDo-rje rnam-par 'joms-pa zhes-bya-ba'i [gzungs] dkyil-'khor-
gyi lag-len go-rims ji-lta-ba zhes-bya-ba* (*Vajravidāranā-nāma-dhāraṇī-
maṇḍala-prakriyā-yathākramanāma*), p. 215, fol. 4. 7.

34. kLong-rdol bLa-ma, *gSang-ngags rig-pa 'dzin-pa'i sde-snod-las byung-
ba'i ming-gi grangs,* p. 33b, 1.

35. Paṇ-chen bLa-ma VI, *bKra-shis rdzas-rtags-kyi bshad-pa khag-cig,* p.
2b, 6.

36. For the original terms in Tibetan and Sanskrit, refer to the glossary
under *activities, four kinds of an enlightened being.*

37. For the original terms in Tibetan and Sanskrit, refer to the glossary
under *aggregates, five.*

38. Tsong-kha-pa, *dPal gsang-ba 'dus-pa mi-bskyod rdo-rje'i dkyil-'khor-gyi
cho-ga dbang-gi don-gyi de-nyid rab-tu gsal-ba,* p. 50a, 3.

39. Yongs-'dzin Khri-zur Byang-chub-chos-'phel, *dPal-ldan stod-rgyud
lugs-kyi rab-gnas dge-legs char-'bebs-kyi ngag-'don phyogs-bsgrigs gsal-
byed me-long,* p. 10a, 1.

40. Paṇ-chen bLa-ma VI, *bKra-shis rdzas-rtags-kyi bshad-pa khag-cig,* p.
2b, 6.

41. Pha-bong-kha-pa Byams-pa-bstan-'dzin-'phrin-las-rgya-mtsho,
*rNam-grol lag-bcangs-su gtod-pa'i man-ngag zab-mo tshang-la ma-nor-
ba mtshungs-med chos-kyi rgyal-po'i thugs-bcud byang-chub lam-gyi
rim-pa'i nyams-khrid-kyi zin-bris gsung-rab kun-gyi bcud-bsdus gdams-
ngag bdud-rtsi'i snying-po,* p. 208b, 4. The Tibetan reads:

/ *ye-shes ji-snyed khyab-gyur-pa* /
/ *sku-yis kyang-ni de snyed-khyab* /

42. Bod-ljongs mTsho-sngon Zi-khron Kan-su'u Yun-nan Shin-cang gi
'phrod-bsten-cus nas bsgrigs, *Bod-sman-gyi tshad-gzhi,* p. 22–25.

43. Monier-Williams, *A Sanskrit-English Dictionary,* p. 366.

44. Paṇ-chen bLa-ma VI, *bKra-shis rdzas-rtags-kyi bshad-pa khag-cig*, p. 3a, 6.

45. Yongs-'dzin Khri-zur Byang-chub-chos-'phel, *dPal-ldan stod-rgyud lugs-kyi rab-gnas dge-legs char-'bebs-kyi ngag-'don phyogs-bsgrigs gsal-byed me-long*, p. 31a, 5.

46. Paṇ-chen bLa-ma VI, *bKra-shis rdzas-rtags-kyi bshad-pa khag-cig*, p. 3b, 2.

47. Paṇ-chen bLa-ma VI, *bKra-shis rdzas-rtags-kyi bshad-pa khag-cig*, p. 3b, 6.

48. Monier-Williams, *A Sanskrit-English Dictionary*, p. 486.

49. Monier-Williams, *A Sanskrit-English Dictionary*, p. 1196.

50. Paṇ-chen bLa-ma VI, *bKra-shis rdzas-rtags-kyi bshad-pa khag-cig*, p. 4a, 3.

51. Paṇ-chen bLa-ma VI, *bKra-shis rdzas-rtags-kyi bshad-pa khag-cig*, p. 4b, 1.

52. Paṇ-chen bLa-ma VI, *bKra-shis rdzas-rtags-kyi bshad-pa khag-cig*, p. 4b, 4.

53. Yongs-'dzin Khri-zur Byang-chub-chos-'phel, *dPal-ldan stod-rgyud lugs-kyi rab-gnas dge-legs char-'bebs-kyi ngag-'don phyogs-bsgrigs gsal-byed me-long*, p. 6b, 6.

54. Paṇ-chen bLa-ma VI, *bKra-shis rdzas-rtags-kyi bshad-pa khag-cig*, p. 4b, 6.

55. *Bod-rgya tshig-mdzod-chen-mo* has the following:

bgegs, vol. 1, p. 467:	*gnod byed 'dre gdon gyi rigs.*
gdon, vol. 2, p. 1353:	*mi min gyi gnod byed cig.*
'dre, vol. 2, p. 1427:	*mi ma yin gyi bye brag cig.*
bdud, vol. 2, p. 1361:	*sems can la gnod 'tshe dan dge ba la bar chad byed mkhen / 'dod lha rigs drug gi nang gses shig.*

56. Böhtlingk, *Sanskrit-Wörterbuch, vighna:* vol. 6, p. 82; *graha:* vol. 2, p. 191; *piśaca:* vol. 4, p. 86; *māra:* vol. 5, p. 70.

57. Sumatiratna, *Bod-hor-kyi brda-yig min-gcig don-gsum gsal-bar byed-pa mun-sel sgron-me*, vol. 1, p. 1067, "*bdud-kyi sde-ni phyi-nang gsang-ba'i bdud gsum-ste / phyi'i bdud-ni gdon-gzugs phyi-rol-tu shar-ba'i rgyal-po the'u-rang sogs-dang / nang-gi bdud-ni sgrib-pa-gnyis /*"

58. (bLa-ma Rin-po-che) lCe-sgom-rdzong-pa, *Man-ngag rin-po-che spungs-pa*, p. 194.

59. Gung-thang dKon-mchog-bstan-pa'i-sgron-me, *bKra shis rdzas-brgyad-kyi rnam-bshad bkra-shis dga'-ston*, p. 5a, 5.

60. Yongs-'dzin Khri-zur Byang-chub-chos-'phel, *dPal-ldan stod-rgyud lugs-kyi rab-gnas dge-legs char-'bebs-kyi ngag-'don phyogs-bsgrigs gsal-byed me-long*, p. 31a, 1.

61. Ratnaśila, *rDo-rje rnam-par 'joms-pa zhes-bya-ba'i [gzungs] dkyil-'khor-gyi lag-len go-rims ji-lta-ba zhes-bya-ba* (*Vajravidāranā-nāma-dhāraṇī-maṇḍala-prakriyā-yathākramanāma*), p. 215, fol. 4. 7. The Tibetan reads:

sngon bcom-ldan-'das śākya thub-pa-la gzugs-kyi lha-mo 'od-'chang-mas me-long phyag-tu phul-te bkra-shis-pa'i rdzas-su byin-gyis brlabs-pa de-bzhin-du / deng 'dir-yang sbyin-pa'i bdag-po 'khor-dang bcas-pa rnams-kyang me-long-gi rdzas-la brten-nas bkra-shis-par gyur-cig /

/ me-long ye-shes rgya-mtsho chen-po yis /
/ ye-shes rgya-mtsho mchog-tu dag-gyur nas /
/ rnam-dag chos-la thogs-med longs-spyod pa'i /
/ bkra-shis des-kyang sgrib-pa dag-gyur cig /

... glang-po-che nor-skyong-gis ghi-wang ...
/ ghi-wang dug-gsum 'joms-pa nad-kyi sman /
/ sman-mchog chos-nyid rab-tu rtogs-gyur te /
/ nyon-mongs zug-rngu med-par gyur-pa yi /
/ bkra-shis des-kyang sdug-bsngal dag-gyur cig /

... zhing-pa'i bu-mo legs-skyes-mas zho ...
/ zho-ni kun-gyi snying-por gyur-pa ste /
/ snying-po rnam-dag ye-shes mchog-rtogs nas /
/ yon-tan kun-gyi dbyings-su gyur-pa yi /
/ bkra-shis des-kyang dug-gsum zhi-gyur cig /

... rtsva-tshong-gi khye'u bkra-shis-kyis rtsva-dur-ba ...
/ dur-bas tshe-ni spel-bar byed-pa ste /
/ rdo-rje sems-dpa'i tshe-ni rab-bsgrubs nas /
/ nyon-mongs skye-shi rgyun-chad gyur-pa yi /
/ bkra-shis des-kyang tshe-yang 'phel-gyur cig /

... lha tshangs-pas shing-tog bil-ba ...
/ bil-ba rgyu-rkyen 'bras-bur bcas-pa'i chos /

/ 'jig-rten 'jig-rten 'das-pa'i spyod-pa kun /
/ byang-chub snying-po mchog-tu dag-gyur pa'i /
/ bkra-shis des-kyang don-kun 'grub-gyur cig /

... lha'i dbang-po brgya-byin-gyis dung g.yas-su 'khyil-pa ...
/ dung-ni chos-kyi sgra-rnams sgrog-pa'i tshul /
/ ye-shes rgya-mtsho nyid-du dag-gyur te /
/ chos-rnams ma-nor yongs-su ston-pa yi /
/ bkra-shis des-kyang tshig-la dbang-thob shog /

... bram-ze skar-rgyal-gyis li-khri...
/ li-khri dmar-po dbang-gi rang-bzhin te /
/ chos-rnams ma-nor dbang-du bsdus-nas kyang /
/ chos-kyi rgyal-srid rtag-tu brtan-gyur pa'i /
/ bkra-shis des-kyang khyed-srid brtan-gyur cig /

... gsang-sngags dang rigs-sngags-kyi bdag-po dpal
 phyag-na rdo-rjes grub-pa'i rdzas yungs-dkar ...
/ yungs-dkar rdo-rje'i rigs-te thams-cad du /
/ bgegs-rnams ma-lus 'joms-par byed-pa yi /
/ mthu-stobs yon-tan phun-sum tshogs-gyur pa'i /
/ bkra-shis des-kyang bgegs-rnams zhi-bar shog /

CHAPTER THREE: THE SEVEN JEWELS OF ROYAL POWER

62. Ratnaśila, rDo-rje rnam-par 'joms-pa zhes-bya-ba'i [gzungs] dkyil-'khor-gyi lag-len go-rims ji-lta-ba zhes-bya-ba (Vajravidāranā-nāma-dhāraṇī-maṇḍala-prakriyā-yathākramanāma), passage; 'Phags-pa dam-pa'i-chos dran-pa nye-bar gzhag-pa (Āryasaddharmānusmṛty-upasthāna), p. 126.5.7.

63. 'Phags-pa dam-pa'i-chos dran-pa nye-bar gzhag-pa (Āryasaddharmānu-smṛty-upasthāna), p. 126.5.7.

64. Liebert, Iconographic Dictionary, p. 53.

65. 'Phags-pa dam-pa'i-chos dran-pa nye-bar gzhag-pa (Āryasaddharmānu-smṛty-upasthāna), pp. 126.4.7, 126.5.7.

66. mNgon-par 'byung-ba'i mdo (Abhiniṣkramaṇasūtra), p. 6.5.6.

67. 'Phags-pa dam-pa'i-chos dran-pa nye-bar gzhag-pa (Āryasaddharmānu-smṛty-upasthāna), p. 126.5.7.

68. Liebert, Iconographic Dictionary, p. 53.

69. Stutley, A Dictionary of Hinduism, p. 58.

70. *rGyu-gdags-pa* (*Kāraṇa-prajñapti*), p. 63.2.4.

71. Monier-Williams, *A Sanskrit-English Dictionary*, p. 858, "*Yojana*,... esp. a partic. measure of distance, sometimes regarded as equal to 4 or 5 English miles, but more correctly = 4 Krośas or about 9 miles; according to other calculations = 2.5 English miles, and according to some = 8 Krośas…"

72. The literal translation of *rgyal-po'am blon-po'i chos-kyi grogs-po* would be "Dharma friends of the ministers or kings," which makes no sense. The passage has been translated as given on the assumption that the genitive form, *blon-po'i*, is a slip of the pen.

73. *'Phags-pa dam-pa'i-chos dran-pa nye-bar gzhag-pa* (*Āryasaddharmānu-smṛty-upasthāna*), p. 127.3.6.

74. Rigzin, *Tibetan-English Dictionary of Buddhist Terminology*, p. 69:

> *rgyal-chen-ris-bzhi; rgyal-po chen-po bzhi; [Skt.] catvāri mahārājakāyika* / The four great kings; the four types of great kings:
> 1. *shar-du Yul-'khor-srung* = Dhṛtarāṣtra in the east;
> 2. *lho-ru 'Phags-skyes-bu* = Virūḍhaka in the south;
> 3. *nub-tu sPyan-mi-bzang* = Virūpakṣa in the west;
> 4. *byang-du rNam-thos-sras* = Vaiśravaṇa or Kuvera in the north;
> the four celestial guardian kings of the four directions of Mount Meru, classified as belonging to desire realm.

75. Dagyab, *Tibetan Religious Art*, part I, p. 114.

76. *rGyu-gdags-pa* (*Kāraṇa-prajñapti*), p. 63.2.6. Note that "demons" have already been discussed in connection with the mustard seeds (p. 58).

77. (Dagyab) Brag-g.yab, L. S., *Bod-brda'i tshig-mdzod*, p. 85.

78. *'Phags-pa dam-pa'i-chos dran-pa nye-bar gzhag-pa* (*Āryasaddharmānu-smṛty-upasthāna*), p. 127.2.2.

79. *rGyu-gdags-pa* (*Kāraṇa-prajñapti*), p. 63.3.8.

80. *'Phags-pa dam-pa'i-chos dran-pa nye-bar gzhag-pa* (*Āryasaddharmānu-smṛty-upasthāna*), p. 126.5.8.

81. *rGyu-gdags-pa* (*Kāraṇa-prajñapti*), p. 63.4.1/3.

82. For the original terms in Tibetan and Sanskrit, refer to the glossary under *enlightenment, seven factors of*.

83. *'Phags-pa dam-pa'i-chos dran-pa nye-bar gzhag-pa* (*Āryasaddharmānu-smṛty-upasthāna*), p. 128.1.2.

84. *rGyu-gdags-pa* (*Kāraṇa-prajñapti*), p. 64.3.8.

85. *'Phags-pa dam-pa'i-chos dran-pa nye-bar gzhag-pa* (*Āryasaddharmānu-smṛty-upasthāna*), p. 127.4.4

86. *rGyu-gdags-pa* (*Kāraṇa-prajñapti*), p. 63.2.8.

87. For the original terms in Tibetan and Sanskrit, refer to the glossary under *miraculous (achievements), four kinds of.*

88. Kirfel, *Symbolik des Hinduismus und des Jainismus*, p. 88.

89. *'Phags-pa dam-pa'i-chos dran-pa nye-bar gzhag-pa* (*Āryasaddharmānu-smṛty-upasthāna*), p. 127.5.8.

90. *rGyu-gdags-pa* (*Kāraṇa-prajñapti*), p. 63.3.6.

91. Gung-thang dKon-mchog-bstan-pa'i-sgron-me, *Maṇḍal-gyi khrid-yig dpag-bsam snye-ma*, fol. 38.

92. *'Phags-pa dam-pa'i-chos dran-pa nye-bar gzhag-pa* (*Āryasaddharmānu-smṛty-upasthāna*), p. 128.1.8.

93. For the original terms in Tibetan and Sanskrit, refer to the glossary under *caste.*

94. *rGyu-gdags-pa* (*Kāraṇa-prajñapti*), p. 63.4.4.

95. Stutley, *A Dictionary of Hinduism*, p. 178; Monier-Williams, *A Sanskrit-English Dictionary*, p. 775.

96. Liebert, *Iconographic Dictionary*, p. 168.

97. Yongs-'dzin Khri-zur Byang-chub-chos-'phel, *dPal-ldan stod-rgyud lugs-kyi rab-gnas dge-legs char-'bebs-kyi ngag-'don phyogs-bsgrigs gsal-byed me-long*, p. 27a, 6. The Tibetan reads:

> / mi-dbang rin-chen sna-bdun 'di-dag ni /
> / sangs-rgyas sras-dang bcas-pa ma-lus la /
> / bsams-shing yid-kyis sprul-te phul-ba yis /
> / 'gro-bas mi-zad gter-la spyod-par shog /
> / oṃ ma hā sapta ratna pū dza me gha āḥ hūṃ svāhā /

> II:/ zhing-'di 'khor-lo rin-chen gyis /:II
> / mkhas-pa dag-gis yongs-bkang ste /
> / dngos-grub 'dod-pa sbyin-pa'i phyir /
> / nyin-re shes-rab can-gyis dbu /
> / oṃ cakra ratna pū dza me gha āḥ hūṃ svāhā /

> / zhing-'di nor-bu rin-po ches / ...
> / oṃ ma ṇi ratna pū dza me gha āḥ hūṃ svāhā /

/ zhing-'di btsun-mo rin-po ches / ...
/ oṃ strī ratna pū dza me gha āḥ hūṃ svāhā /

/ zhing-'di blon-po rin-po ches / ...
/ oṃ pu ru ṣa ratna pū dza me gha āḥ hūṃ svāhā /

/ zhing-'di glang-po rin-po ches / ...
/ oṃ ga ja ratna pū dza me gha āḥ hūṃ svāhā /

/ zhing-'di rta mchog rin-po ches / ...
/ oṃ a śva ratna pū dza me gha āḥ hūṃ svāhā /

/ zhing-'di dmag-dpon rin-po ches / ...
/ oṃ khaṅga ratna pū dza me gha āḥ hūṃ svāhā /

CHAPTER FOUR: THE SEVEN SECONDARY JEWELS

98. *'Phags-pa dam-pa'i-chos dran-pa nye-bar gzhag-pa* (*Āryasaddharmānu-smṛty-upasthāna*), p. 128.2.1.

99. *'Phags-pa dam-pa'i-chos dran-pa nye-bar gzhag-pa* (*Āryasaddharmānu-smṛty-upasthāna*), p. 128.5.2.

100. kLong-rdol bLa-ma, *gSang-ngags rig-pa 'dzin-pa'i sde-snod-las byung-ba'i ming-gi grangs*, fol. 156.3. The seven precious stones are listed here with their original Tibetan and Sanskrit names: ruby (*padma-ra-ga*, Skt. *padmarāga*), sapphire (*in-dra-nī-la*, Skt. *indranīla*), lapis lazuli (*bāi-durya*, Skt. *vaiḍūrya*), emerald (*mar-gad*, Skt. *marakata*), diamond (*rdo-rje*, Skt. *vajra*), pearl (*mu-tig*, Skt. *muktikā*), and coral (*byu-ru*, Skt. *vidruma*).

101. *'Phags-pa dam-pa'i-chos dran-pa nye-bar gzhag-pa* (*Āryasaddharmānu-smṛty-upasthāna*), p. 128.2.6. For the sake of easy reading, the repeated phrase "secondary jewel" (*ne-ba'i rin-po-che*) has, at times, been rendered simply as "precious."

CHAPTER FIVE: THE SEVEN GEMS

102. Dagyab, *Tibetan Religious Art*, part II, p. 30.

103. Waddell, *The Buddhism of Tibet*, p. 391.

104. Olschak and Wangyal, *Mystic Art of Ancient Tibet*, p. 45.

105. kLong-rdol bLa-ma, *gSang-ngags rig-pa 'dzin-pa'i sde-snod-las byung-ba'i ming-gi grangs*, fol. 157.1.

CHAPTER SIX: THE SIX SIGNS OF LONG LIFE

106. (Brag-ri Rin-po-che), Brag-ri sPrul-ming-pa bLo-bzang-lung-rigs-rgya-mtsho-dbang-rgyal, *rDo-rje-'chang pha-bong-kha-pa bde-chen snying-po dpal-bzang-po'i phyag-bzhes gtor-ma brgya-rtsa gtong-tshul-gyi man-ngag nag-'gros-su bkod-pa sku-gsum nor-bu 'dren-pa'i mchod-sbyin 'phrul-gyi shing-rta*, ff. 512.1–519.6.

107. Paṇ-chen bLa-ma VI, *Tshe-ring ljongs-drug-gi dpal-yon-la bstod-pa*, ff. 816–818.

CHAPTER SEVEN: THE FIVE QUALITIES OF ENJOYMENT

108. These five are listed here with their original Tibetan and Sanskrit names: visual form (*gzugs*, Skt. *rūpa*), sound (*sgra*, Skt. *śabda*), smell (*dri*, Skt. *gandha*), taste (*ro*, Skt. *rasa*), and tactile quality (*reg-bya*, Skt. *sparśa*).

109. Kun-dga'-snying-po, *rGyud-kyi rgyal-po chen-po dpal gsang-ba 'dus-pa'i rgya-cher 'grel-pa* (*Śrīguhyasamājamahātantrarājaṭīkā*), p. 127.4.8.

110. Yongs-'dzin Khri-zur Byang-chub-chos-'phel, *dPal-ldan stod-rgyud lugs-kyi rab-gnas dge-legs char-'bebs-kyi ngag-'don phyogs-bsgrigs gsal-byed me-long*, p. 27a, 4.

111. Kun-dga'-snying-po, *rGyud-kyi rgyal-po chen-po dpal gsang-ba 'dus-pa'i rgya-cher 'grel-pa* (*Śrīguhyasamājamahātantrarājaṭīkā*), p. 127.4.8.

112. Yongs-'dzin Khri-zur Byang-chub-chos-'phel, *dPal-ldan stod-rgyud lugs-kyi rab-gnas dge-legs char-'bebs-kyi ngag-'don phyogs-bsgrigs gsal-byed me-long*, p. 27a, 5. The Tibetan reads:

> / rgyal-ba zag-med 'byor-la mnga'-bsgyur yang /
> / 'gro-ba'i don-du 'dod-yon rnam-lnga yis /
> / mchod-pas mkha'-mnyam sems-can thams-cad-kyis /
> / bsod-nams mi-zad gter-la spyod-par shog /
> / oṃ bajra samanta bha dra pū dza me gha āḥ hūṃ svāhā /

> / rin-chen dbang-gi rgyal-po vai-ḍūrya /
> / sngon-po la-sogs kha-dog dbyibs-kyi gzugs /
> / rnam-gsum gzugs-kyi rdo-rje mar-byas nas /
> / bla-ma lha-yi spyan-la dbul-bar bya /
> / oṃ rū pa pū dza me gha āḥ hūṃ svāhā /

/ ma-zin 'byung-ba'i tshogs-pa las-byung ba'i /
/ brjod-bral dbyangs-la sogs-pa sgra-yi tshogs /
/ rnam-gsum sgra-yi rdo-rje mar-byas nas /
/ bla-ma lha-yi snyan-la dbul-bar bya /
/ oṃ śapta pū dza me gha āḥ hūṃ svāhā /

/ ga bur a-kar dza-ti la-sogs pa /
/ legs-par sbyar-las byung-ba dri-yi tshogs /
/ rnam-gsum dri-yi rdo-rje mar-byas nas /
/ bla-ma lha-yi shangs-la dbul-bar bya /
/ oṃ gandhe pū dza me gha āḥ hūṃ svāhā /

/ lus-mchog brtas-byed bdud-rtsi'i zas-sogs kyi /
/ mngar-skyur kha-dang bska-la sogs-pa'i ro /
/ rnam-gsum ro-yi rdo-rje mar-byas nas /
/ bla-ma lha-yi ljags-la dbul-bar bya /
/ oṃ ra sa pū dza me gha āḥ hūṃ svāhā /

/ lus-la reg-pa tsam-gyis bde-ster ba /
/ dpag-bsam gos-la sogs-pa reg-bya'i tshogs /
/ rnam-gsum reg-bya'i rdo-rje mar-byas nas /
/ bla-ma lha-yi sku-la dbul-bar bya /
/ oṃ sparśa pū dza me gha āḥ hūṃ svāhā /

CHAPTER EIGHT: THE FOUR HARMONIOUS BROTHERS

113. 'Dul-ba-gzhi (Vinayavastu), p. 312.4.5.

114. Panglung, *Die Erzählstoffe des Mūlasarvāstivāda-vinaya, analysiert auf Grund der tibetischen Übersetzung*, p. 78.

115. Klaus Sagaster has dealt with the Mongolian versions of this fable in his book, *Der Weiße Lotus des Friedens*, pp. 485, 498.

CHAPTER NINE: THE THREE SYMBOLS OF VICTORY IN THE FIGHT AGAINST DISHARMONY

116. A *garuḍa* (*khyung*) is a mythical bird, similar to an eagle but of gigantic proportions.

117. A-khu Shes-rab-rgya-mtsho, *Grub-chen lū-i-pa'i lugs-kyi dpal 'khor-lo sdom-pa'i bskyed-rim he-ru-ka'i zhal-lung*, p. 50a, 6.

GLOSSARY

ENGLISH	TIBETAN	SANSKRIT
abandonments, pure	yang-dag spong-ba	samyakprahāna
four pure —	yang-dag spong-ba bzhi	catvāri samyakprahāna
concentration on the basis of —	spong-ba bsam-gtan-gyi 'khor-lo	
perfect —	spangs-pa phun-tshogs	
— (of delusion) and attainments (of wisdom)	spangs rtogs	
actions	las	karma
pure supramundane —	'jig-rten-las 'das-pa'i yang-dag-pa'i spyod-pa	
pure mundane —	yang-dag-pa'i spyod-pa	
activities, four kinds of an enlightened being	las-bshi, 'phrin-las-bzhi	catvāri samudacāra
peaceful —	zhi-ba'i las	śānticāra
— of increase	rgyas-pa'i las	vipulacāra
— of power (or control)	dbang-gi las	bhāgyacāra
— of wrath	drag-po'i las	raudracāra
aggregates, five (psycho-physical constituents, *skandhas*):	phung-po lnga	pañca skandha
form	gzugs	rūpa
feeling (sensation)	tshor-ba	vedanā
perception	'du-shes	saṃjñā
karmic formations	'du-byed	saṃskāra
consciousness	rnam-par shes-pa	vijñāna
Ākāśagarbha	Nam-mkha'i snying-po	Ākāśagarbha
Akṣobhya	Mi-bskyod-pa	Akṣobhya
Amitābha	'Od-dpag-med	Amitābha
Amitāyus	Tshe-snang-dpag-med = Tshe-dpag- med	Amitāyus
Amoghasiddhi	Don-yod-grub-pa	Amoghasiddhi
Ānanda	Kun-dga'-bo	Ānanda

ENGLISH	TIBETAN	SANSKRIT
antelope of long life	ri-dvags tshe-ring	
arrogance	nga-rgyal	
attachment, craving	'dod-chags	rāgā
attainment, perfect	rtogs-pa phun-tshogs	
attitude, wrong (defilement)	nyong-mongs	kleśa
Avalokiteśvara	sPyan-ras-gzig	Avalokiteśvara
awareness, supernormal	mngon-shes	
banner (with animals)	ba-dan (rgyal-mtshan)	dhvaja
banner (without animals)	ba-dan	pataka
banner	phan	paṭṭa
bardo beings	bar-do-ba	
beings (living beings)	sems-dpa'	sattva
benefit	don	
two kinds of —	don-gnyis	
perfection of — for others	gzhan-don phun-tshogs	
perfection of — for oneself	rang-don phun-tshogs	
bilva fruit	shing-tog bil-ba	bilva
bird of long life	bya tshe-ring	
blessed one	bcom-ldan-'das	bhagavān
bliss	bde-ba	
and emptiness	bde stong	
non-dual — and emptiness	bde-stong gnyis-su med-pa	
bodhicitta	byang-chub kyi sems	bodhicitta
Bringers of Good Fortune, Eight	bkra-shis rdzas-brgyad	aṣṭamaṅgaladravya
Brothers, the Four Harmonious	mthun-po spun-bzhi	catvāri anukulabhrātṛ
buddha	sangs-rgyas	buddha
four activities of a —	las-bzhi, 'phrin-las-bzhi	catvāri samudacāra
perfect —	yang-dag-par rdzogs-pa'i sangs-rgyas	samyak-sambuddha
— families, five	rgyal-ba rigs-lnga	pañca-jina
burnt-offering ceremony	sbyin-sreg	homa
by nature	rang-bzhin-gyis	
Cakrasaṃvara	'Khor-lo bde-mchog	Cakrasaṃvara
cakravartin (universal monarch)	'Khor-lo bsgyur-ba'i rgyal-po	cakravartin
canonical texts, set of (*Kangyur*)	bKa'-'gyur	
caste, royal	rgyal-rigs	kṣatrīya
priestly —	bram-ze'i-rigs	brāhmaṇa
middle —	rje'u-rigs	vaiśya
lower —	dmangs-rigs	śūdra

ENGLISH	TIBETAN	SANSKRIT
chü (essence, "juice")	bcud	
cinnabar	li-khri	sindūra
clarity	gsal-ba	
completely perfect buddha	yang-dag-par rdzogs-pa'i sangs-rgyas	samyak-sambuddha
concentration	ting-nge-'dzin	
— on the basis of abandonment	spong-ba bsam-gtan-gyi 'khor-lo	
training in —	bslab-pa ting-nge-'dzin-gyi bslab-pa	
— mandala	bsam-gtan-gyi dkyil-'khor	
conch shell	dung	śaṅkha
right-turning —	dung g.yas-'khyil	dakṣiṇāvataśaṅkha
confidence due to aspiration	mngon-'dod-kyi dad-pa	
confidence due to belief	yid-ches-kyi dad-pa	
confidence due to purity of mind (heart)	dvangs-ba'i dad-pa	
consciousness	rnam-par shes-pa, rig-pa	vijñāna, vidyā
subtle —	sems-nyid	
most subtle —	gnyug-sems	
purified sphere of —	dbyings	dhātu
main —	gtso-sems	
ebullitions of — (mental factors)	sems-byung	
continent, northern	sGra-mi-snyan	
eastern —	Lus-'phags	
southern —	'Dzam-bu-ling	Jambudvīpa
western —	Ba-lang-spyod	
coral	byu-ru	vidruma
eight-branched —	byu-ru yan-lag brgyad-pa	
crimson color	btsod-kha	
cult picture, miniature	tsak-li	
cymbals	ting-shag	
ḍāka	dpa'-bo	ḍāka
ḍākinī	mkha'-'gro	ḍākinī
defilement (wrong attitude)	nyon-mongs	kleśa
delusion	gti-mug	moha
demigods	lha-ma-yin	asura
demons, hindering	bgegs	vighna
harmful —	gdon	graha
(hinderance, interference —)	bdud	māra

ENGLISH	TIBETAN	SANSKRIT
demons *(cont'd.)*		
(non-human beings)	'dre	piśāca
ritual for banishing —	bgegs-gtor	
dependence	'brel	
abiding in —	rten-'brel	
arising in —	rten-'byung	
dependent existence	rten-'brel	
dependent origination	rten-'byung	
Dharma chos	dharma	
wheel of —	chos-kyi 'khor-lo	
wealth of —	chos-kyi dpal-'byor	
kingdom of —	chos-kyi rgyal-srid	
Dharmadhātu	chos-kyi dbyings	dharmadhātu
diamond, vajra	rdo-rje	vajra
disharmony	mi-mthun	
all kinds of external and internal —	phyi-nang-gi mi-mthun 'phyogs	
banner of victory in the fight against —	mi-mthun g.yul-las rgyal-ba'i rgyal-mtshan	
distinctive feature	khyad-chos	
distinguishing mark	mtshan-ma	
divine realm of the four great kings	rgyal-chen bzhi'i lha-gnas	
divine surroundings, two kinds of	lha'i rigs gnyis	
doctrine, Dharma	chos	dharma
dominion of knowledge	mkhyen-srid	
Dzambu River	'Dzam-bu'i chu	
dūrvā grass	rtsva-dur-ba	dūrvā
earrings, pair for a king	rgyal-po'i rna-cha	
earrings, pair for a queen	bstun-mo'i rna-cha	
earthly deities	sa-lha	
Eight Bringers of Good Fortune	bkra-shis rdzas-brgyad	aṣṭamaṅgaladravya
Eight Symbols of Good Fortune	bkra-shis rtags-brgyad	aṣṭamaṅgala
elephant, precious	glang-po rin-po-che	hastiratna
elephant's tusks	glang-chen mche-ba	
emerald	mar-gad	marakata
empowerment	dbang	abhiṣeka
emptiness	stong-pa-nyid	śūnyatā
bliss and —	bde-stong	
Enjoyment, Five Qualities of	'dod-yon sna-lnga	pañcakāmaguṇā
enlightenment, highest essence of (buddhahood)	byang-chub snying-po mchog	

ENGLISH	TIBETAN	SANSKRIT
enlightenment *(cont'd.)*		
mind of —	byang-chub-kyi sems	bodhicitta
seven factors of —:	byang-chub yan-lag bdun	sapta bodhyaṅga
factor of perfect mindfulness	dran-pa yang-dag byang-chub- kyi yan-lag	smṛti-saṃbodhyaṅgam
factor of perfect wisdom thoroughly distinguishing phenomena	chos rab-tu rnam-par 'byed-pa yang-dag byang-chub-kyi yan-lag	dharma-pravicaya-saṃbodhyaṅgam
factor of perfect (joyous) effort	brtson-'grus yang-dag byang-chub-kyi yan-lag	vīrya-saṃbodhyaṅgam
factor of perfect joy	dga'-ba yang-dag byang-chub-kyi yan-lag	prīti-saṃbodhyaṅgam
factor of perfect pliancy	shin-sbyangs yang-dag byang-chub-kyi yan-lag	prasrabdhi-saṃbodhyaṅgam
factor of perfect concentration	ting-'dzin yang-dag byang-chub-kyi yan-lag	samādhi-saṃbodhyaṅgam
factor of perfect equanimity	btan-snyoms yang-dag byang-chub-kyi yan-lag	upekṣā-saṃbodhyaṅgam
envy	phrag-dog	
essence	snying-po	
own —	rang-gi ngo-bo	
secret — of spoken words	gsung-gi gsang-ba'i gnad	
pure —	snying-po rnam-dag	
explanation and realization	bshad sgrub	
feeling (sensation)	tshor-ba	vedanā
field (also for mandala)	zhing	
firmly remaining (ritual)	brtan-bzhugs	
foe destroyer	dgra-bcom-pa	arhat
Form Body (enlightened body in relation to form)	gzugs-sku	rūpakāya
form	gzugs	rūpa
form realm	gzugs-khams	rūpadhātu
formless realm	gzugs-med-khams	arūpadhātu
Four Harmonious Brothers	mthun-po rkang-pa bzhi	catvāri anukulabhrātṛ
four great kings	rgyal-chen bzhi	
four groups [of what can be wished for]: Dharma, wealth, love, and liberation	chos/ nor/ 'dod-pa/ thar-pa	
four kinds of miraculous (achievement)	rdzu-'phrul rkang-pa bzhi	catvāri ṛddhipāda
freedom from disturbing conceptions	mi-rtog-pa	
fruition, path and	lam-'bras	

ENGLISH	TIBETAN	SANSKRIT
fruits	shing-tog	phala
fur-bearing fish	nya spu rgyas-pa	
Gandhavajradevī	Dri-rdo-rje-ma	Gandhavajradevī
garden	tshal	vana
garments	gos	cīvara
garuḍa	khyung	garuḍa
gem, three-eyed	nor-bu mig-gsum-pa	
crossed —s	nor-bu bskor-cha	
Seven Gems	nor-bu cha-bdun	
general, precious	dmag-dpon rin-po-che	senāpatiratna
ghiwang medicine	ghi-wang	gorocanā
gods and humans who have accomplished the word of truth	lha-mi bden-tshig grub-pa	
gods born together with [the offerer]	lhan-cig skyes-pa'i lha	
gods	lha	deva
gods of wealth	nor-lha	
gods who protect [the offerer]	'tsho-ba'i lha; srung-shing skyob-pa'i lha	
golden fishes	gser-nya	
good house	khang-bzang	harmya
grass, *dūrvā*	rtsva dur-ba	dūrvā
gratification, ritual for	bskang-gso	
Great Vehicle	theg-pa chen-po	mahāyāna
guests, higher	yar-mgron	
middle-ranking —	bar-mgron	
lower —	mar-mgron	
hand gesture, symbolic	phyag-rgya	mudrā
happiness and suffering	bde sdug	
hare	ri-bong	śaśa
harmful demons	gdon	graha
—and hindering demons	gdon bgegs	graha vighna
hatred	zhe-sdang	dveṣa
hearing, thinking, meditating	thos bsam sgom-pa	
hell being	dmyal-ba	narak
hide (of an animal)	pags-pa	carman
horse, precious	rta-mchog rin-po-che	aśvaratna
hungry ghost(s)	yi-dvags	preta
— who wait for leftovers	lhag-la re-ba'i yi-dvags	
ignorance, fundamental (= delusion	ma-rig-pa gti-mug)	moha

ENGLISH	TIBETAN	SANSKRIT
incense vessel	spos-snod	
increase, activity of	rgyas-pa'i las	vipulacāra
jewel	nor-bu	
precious —	nor-bu rin-po-che	maniratna
Seven Jewels of Royal Power	rgyal-srid rin-chen sna-bdun	saptaratna
Seven Secondary Jewels	nye-ba'i rin-chen bdun	sapta upāratna
Three Jewels	dkon-mchog-gsum	triratna
Jñānapāda	Ye-shes zhabs	Jñānapāda
juice (essence, quality)	bcud	
karma	las	karma
subtle and gross winds of —	las-rlung pha-rags	
karmic formations	'du-byed	saṃskāra
knot, glorious (endless)	dpal be'u	śrīvatsa
knowing whatever is to be known	ji-snyed-pa rtogs-pa'i ye-shes	
Kālacakra	Dus-kyi 'khor-lo	Kālacakra
Kṣitigarbha	Sa-yi snying-po	Kṣitigarbha
lama	bla-ma	guru
lapis lazuli	bāi-ḍūrya	vaiḍūrya
liberation	thar-pa	
limb (factor)	yan-lag	
seven —s	yan-lag bdun	
lion, eight-legged	sengge rkang-pa brgyad-pa	
living being	'gro-ba	
local gods	yul-lha	
Long Life, Six [Signs] of	tshe-ring druk-skor	
long-life ceremony "firmly remaining"	brtan-bzhugs	
lotus	padma	padma
love	'dod-pa	kāma
lute	pi-wang	vīṇā
main consciousness	gtso-sems	
makara crocodile	chu-srin ma-ka-ra	
man of long life	mi tshe-ring	
mandala	dkyil-'khor	maṇḍala
— constructed as a model	blos-blangs-kyi dkyil-'khor	
— drawn on cloth	ras-bris-kyi dkyil-'khor	
— made in sand	rdul-tshon-gyi dkyil-'khor	
— produced by concentration	bsam-gtan-gyi dkyil-'khor	

ENGLISH	TIBETAN	SANSKRIT
māra	bdud	māra
meditation, wisdom arising from	sgom-byung-gi ye-shes	
meditational (tantric) deity	yi-dam	iṣṭadevatā
meditating: hearing, thinking, —	thos bsam sgom-sum	
mental body	yid-lus	
mental factors, "ebullitions" of consciousness	sems-byung	
merits	bsod-nams	
method, union of — and wisdom	thabs-shes zung-'brel	
miniature cult picture	tsak-li	
minister, precious	blon-po rin-po-che	pariṇāyakaratna
miraculous (achievements), four kinds of:	rdzu-'phrul rkang-pa bzhi	catvāri ṛddhipāda
miraculous analysis	dpyod-pa'i rdzu-'phrul-gyi rkang-pa	mīmaṃsā ṛddhipāda
miraculous aspiration	'dun-pa'i rdzu-'phrul-gyi rkang-pa	chanda ṛddhipāda
miraculous effort	brtson-'grus-kyi rdzu-'phrul-gyi rkang-pa	vīrya ṛddhipāda
miraculous intention	bsam-pa'i rdzu-'phrul-gyi rkang-pa	citta ṛddhipāda
mirror	me-long	ādarśa
miserliness	ser-sna	
monkey	spre'u	kapi
mustard seeds	yungs-kar	sarṣapa
Nature Body	ngo-bo nyid sku	svabhāvikakāya
negative mental states	gnod-sems	
nirvana samsara and —	mya-ngan-las 'das-pa 'khor-'das	nirvāṇa
nominal imputation, existing only by	ming-rkyang btags-yod tsam	
non-dual bliss and emptiness	bde-stong gnyis-su med-pa	
not abiding in peace	zhi-la mi gnas	
nāga	klu	nāga
obstructions	sgrib-pa	
two kinds of —	sgrib-pa-gnyis	
painted scroll	thang-ga	
parasol	gdugs	chattra
yellow central —	dkyil-gdugs ser-po	
partridge	gong-ma-sreg	kapiñjala
path and fruition	lam-'bras	

ENGLISH	TIBETAN	SANSKRIT
perception	'du-shes	samjñāna
perfect dwelling (ritual)	rab-gnas	
poisons, three:	dug-gsum	
attachment, craving	'dod-chags	rāgā
hatred	zhe-sdang	dveṣa
delusion	gti-mug	moha
preciousness, precious object	rin-po-che	
preta (hungry ghost)	yi-dvags	preta
protectors of religion	chos-srung/chos skyong	
Qualities of Enjoyment, Five	'dod-yon sna-lnga	pañcakāmaguṇā
queen, precious	btsun-mo rin-po-che	rājñīratna
Rasavajradevī	Reg-bya-rdo-rje-ma	Rasavajradevī
Ratnasambhava	Rin-chen-'byung-ldan	Ratnasambhava
realization, explanation and	bshad grub	
realm of desire, desire realm	'dod-pa'i khams, 'dod-khams	kāmadhātu
gods of the —	'dod-lha	kāmadevā
representational beings	dam-tshig-pa	samayasattva
rite for bringing about a fortunate destiny	g.yang-sgrub	
ritual for "firmly remaining"	brtan-bzhugs	
ritual for banishing hindering demons	bgegs-gtor	
ritual for gratification	bskang-gso	
ritual for "perfect dwelling"	rab-gnas	
rock of long life	brag tshe-ring	
ruby	padma-rᴏ-ga	padmarāga
Rūpavajradevī	gZugs-rdo-rje-ma	Rūpavajradevī
Śabdavajradevī	sGra-rdo-rje-ma	Śabdavajradevī
sacrificial ball	gtor-ril	
sacrificial cake	gtor-ma	
Śākyamuni	Śākya thub-pa	Śākyamuni
sameness wisdom	mnyam-nyid ye-shes	
samsara	'khor-ba	saṃsāra
— and nirvana	'khor-'das	
sapphire	in-dra-nı-la	indranīla
Sarvanīvaraṇaviṣkambhī	sGrib-pa thams-cad rnam-par sel-ba	Sarvanīvaraṇaviṣkambhī
seat	mal-cha	śayana
secondary preciousness	nye-ba'i rin-po-che	

ENGLISH	TIBETAN	SANSKRIT
self-illuminating glory	rang-mdangs	
shoes	lham	pulā
sign of victory	rgyal-mtshan	dhvaja
sign, auspicious	rten-'brel	
sign (mark, symbol, indication)	rtags	
silk	dar	netra
silk scarf (for offering)	kha-btags	
skandhas, five (aggregates)	phung-po lnga	pañca skandha
sky, heavens, space	nam-mkha'	
smell	dri	gandha
sound	sgra	śabda
supernormal awareness	mngon-shes	
sword	ral-gri	khaḍga
sword-wheel	ral-gri'i-'khor-lo	
Symbols of Good Fortune, Eight	bkra-shis rtags-brgyad	aṣṭamaṅgala
tactile quality	reg-bya	sparśa
taste	ro	rasa
tendencies, latent	bag-chags	vāsanā
tendrel	rten-'brel	
texts, set of canonical —	bKa'-'gyur	
thinking: hearing, —, and meditating	thos bsam sgom-pa	
Three Jewels	dkon-chog gsum	triratna
three poisons	dug-gsum	tri viṣa
three realms:	khams gsum	
desire realm	'dod-pa'i khams, 'dod -khams	kāmadhātu
form realm	gzugs-khams	rūpadhātu
formless realm	gzugs-med-kham	arūpadhātu
Thus Gone (= the Buddha)	de-bzhin-gshegs-pa	tathāgata
training, three kinds of:	bslab-pa gsum	trīṇiśikṣa
— in moral discipline	bslab-pa tshul-khrims-kyi bslab-pa	
— in concentration	bslab-pa ting-nge-'dzin-gyi bslab-pa	
— in wisdom	bslab-pa shes-rab-kyi bslab-pa	
treasure vase	gter-chen-po'i bum-pa	kalaśa
tree of long life	shing tshe-ring	
Truth Body (enlightened body in relation to mind)	chos-sku	dharmakāya

ENGLISH	TIBETAN	SANSKRIT
truth, taken to be	bden-'dzin	
unicorn	bse-ru	
Vairocana	rNam-par-snang-mdzad	Vairocana
Vaiśravaṇa (guardian of wealth)	rNam-thos-sras	Vaiśravana
vajra (diamond, lord of stones)	rdo-rje	vajra
vajra-being *(vajrasattva)*	rdo-rje sems-dpa'	vajrasattva
holder of the —	rdo-rje-'chang	vajradhara
— teacher	rdo-rje slob-dpon	
vase (for treasure)	(gter-chen-po'i) bum-pa	kalaśa
vessel and contents	snod bcud	
victor(s)	rgyal-ba	jina
sons of the —	rgyal-ba'i sras	
Victory in the Fight Against Disharmony, Symbols of	mi-mthun g.yul-rgyal	
view, mundane pure	'jig-rten-pa'i yang-dag-pa'i lta-ba	
supramundane pure —	'jig-rten-las 'das-pa'i yang-dag-pa'i lta-ba	
washing ceremony	khrus-gsol	
water of long life	chu tshe-ring	
water offering	chab-gtor	
wealth	nor	
gods of	nor-lha	
weapon-wheel, wrathful	drag-po'i mtshon-cha 'khor-lo	
wrathful — with 18 spokes	rtse-mo bco-brgyad-pa'i drag-po'i mtshon-cha 'khor-lo	
wheel	'khor-lo	cakra
precious —	'khor-lo rin-po-che	
three wheels:	'khor-lo-gsum	
study (= reading, hearing, thinking)	klog-pa thos bsam-gyi 'khor-lo	
concentration based on abandonments	spong-ba bsam-gtan-gyi 'khor-lo	
action (activities)	bya-ba las-kyi 'khor-lo	
— of Dharma (Buddhist doctrine)	chos-kyi 'khor-lo	dharmacakra
winds of karma, subtle and gross	las-rlung phra-rags	
wisdom and method, union of	thab-shes zung-'brel	
wisdom, training in	bslab-pa shes-rab-kyi bslab-pa	

ENGLISH	TIBETAN	SANSKRIT
wisdom *(cont'd.)*		
highest —	ye-shes-kyi mchog	
five —s	ye-shes lnga	
— of the *Dharmadhātu*	chos-kyi dbyings-kyi ye-shes	
— of equality	mnyam-nyid ye-shes	
— realizing emptiness	de-kho-na-nyid rtogs-pa'i shes-rab	
— arising from meditation	sgom-byung-gi ye-shes	
perfect — of a buddha (Truth Body)	chos-sku	dharmakāya
— being	ye-shes-pa	jñānasattva
Wisdom Truth Body	ye-shes chos-sku	jñānadharmakāya
word of truth	bden-tshig	
gods and humans who have accomplished the —	lha-mi bden-tshig grub-pa	
wrathful activities	drags-po'i las	raudracāra
implementation of —	drags-po'i phrin-las	
yogurt	zho	dadhi
yojana (measure of length)	dpag-tshad	yojana
yak	g.yag/ 'dri	
yakṣa	gnod-sbyin	yakṣa
yakṣiṇī (kind of)	'phrog-ma	yakṣiṇī

BIBLIOGRAPHY

Böhtlingk, Otto. *Sanskrit-Wörterbuch in kürzerer Fassung.* Graz, 1959, Vol. I–VII.

Dagyab, Loden Sherap. *Tibetan Religious Art.* Part I: Texts, Part II: Plates. Asiatische Forschungen 52. Wiesbaden, 1977.

Kirfel, Willibald. *Symbolik des Buddhismus.* Vol. V. of Symbolik der Religionen. Series edited by Ferdinand Herrmann. Stuttgart, 1959.

——————. *Symbolik des Hinduismus und des Jainismus.* Vol. IV of Symbolik der Religionen. Series edited by Ferdinand Herrmann. Stuttgart, 1959.

Liebert, Gösta. *Iconographic Dictionary of the Indian Religions.* Vol. V. of Studies in South Asian Culture. Edited for the Institute of South Asian Archaeology, University of Amsterdam, by J. E. van Lohuizen-de Leeuw. Leiden, 1976.

Moeller, Volker. *Symbolik des Hinduismus und des Jainismus.* Vol. XIX of Symbolik der Religionen [volume of plates accompanying Vol. IV of the text series]. Series edited by Ferdinand Herrmann. Stuttgart 1974.

Monier-Williams, Sir Monier, *A Sanskrit-English Dictionary: Etymologically and Philologically Arranged with Special Reference to Cognate Indo-European Languages.* Oxford, 1899. Reprinted 1979.

Olschak, Blanche Christine, in collaboration with Geshe Thupten Wangyal. *Mystic Art of Ancient Tibet.* London, 1973.

Panglung, Jampa Losang. *Die Erzählstoffe des Mūlasarvāstivāda-vinaya, analysiert auf Grund der tibetischen Übersetzung.* Stud. Philol. Buddhica, Monograph Series, III. Tokyo, 1981.

Rigzin, Tsepak. *Tibetan-English Dictionary of Buddhist Terminology, Nang-don rig-pa'i ming-tshig bod-dbyin shan-sbyar.* Published by the Library of Tibetan Works and Archives, New Delhi, 1986.

Sagaster, Klaus. *Der Weiße Lotus des Friedens.* Zentralasiatische Studien, 12 (1978).

Stutley, Margaret and James. *A Dictionary of Hinduism: Its Mythology, Folklore and Development 1500 BC– AD 1500.* London, Melbourne, and Henley, 1977.

Suzuki, Daisetz T. (ed.). *The Tibetan Tripitaka.* Peking edition. Vols. 1–45: *Bkaḥ-Hgyur.* Vols. 46–150: *Bstan-Hgyur.* Vol. 151: *Dkar-Chag.* Vols. 152–164: *Extra*

(*Tson-kha-pa / Lcan-Skya*). Vols. 165–168: *Catalogue*. Reprinted under the supervision of the Otani University, Tokyo and Kyoto, 1955–61.

Waddell, L. Austine, *The Buddhism of Tibet or Lamaism with Its Mystic Cults, Symbolism and Mythology, and in Its Relation to Indian Buddhism*. New edition. Cambridge, 1967.

TIBETAN ORIGINAL TEXTS

Entries are arranged in Tibetan alphabetical order by author. Texts without an author (e.g., canonical works) are listed by title, prior to the other entries. "P" refers to entries in the Peking edition of the *Tibetan Tripitaka* (see above under Suzuki, Daisetz T.).

dGa'-ldan dar-rgyas gling-gi chos-spyod-las mnga'-'bul-skor bzhugs-so. In *dGa'-ldan dar-rgyas gling-gi chos-spyod*. Tibetan original edition from bKra-shis-lhun-po, n.d.

rGyu-gdags-pa (*Kāraṇa-prajñapti*). P5588, Vol. 115.

mNgon-par 'byung-ba'i mdo (*Abhiniṣkramaṇasūtra*). P967, Vol. 39.

'Dul-ba'i gzhi (*Vinayavastu*). P1030, Vol. 41.

'Phags-pa bkra-shis brtsegs-pa zhes-bya-ba theg-pa chen-po'i mdo (*Āryamaṅgalakūṭanāma-mahāyānasūtra*). In *gZungs-bsdus,* Bibliothèque Nationale, Paris, Fonds tibetain 492, ff. 874a–880b (after a microfilm of the Service Photographique). Described by Marcelle Lalou in *Catalogue du Fonds tibetain de la Bibliothèque Nationale*. IVme partie: I. Les mdo-mang. Paris 1931. (Buddhica. 2me serie: Documents. IV.), No. 200 (p. 73).

'Phags-pa dam-pa'i-chos dran-pa nye-bar gzhag-pa (*Āryasaddharmānusmṛty-upasthāna*). P953, Vol. 37.

Bod-rgya tshig-mdzod chen-mo. Produced under the direction of Krang-dbyi-sun. 3 vols. Beijing, 1984.

Kun-dga'-snying-po. *rGyud-kyi rgyal-po chen-po dpal gsang-ba 'dus-pa'i rgya-cher 'grel-pa* (*Śrīguhyasamājamahātantrarājaṭīkā*). P4787, Vol. 84.

kLong-rdol bLa-ma. *gSang-ngags rig-pa 'dzin-pa'i sde-snod-las byung-ba'i ming-gi grangs*. In *The Collected Works of Longdol Lama*. Parts 1 and 2. Reproduced by Lokesh Chandra from the collections of Prof. Raghu Vira. Śata-piṭaka series, Indo-Asian Literature. New Delhi, 1973, Vol. 100, ff. 91–174.

Khri-byang Rin-po-che, bLo-bzang-ye-shes-bstan-'dzin-rgya-mtsho. *dGa'-ldan khri-chen byang-chub chos-phel-gyi skye-gral-du rlom-pa'i gyi-na-pa zhig-gis rang-gi ngang-tshul ma-bcos lhug-par bkod-pa 'khrul-snang sgyu-ma'i zlos-gar*. Print from Khri-byang bla-brang. New Delhi, 1975.

Gung-thang dKon-mchog-bstan-pa'i-sgron-me. *bKra shis rdzas-brgyad-kyi rnam-*

bshad bkra-shis dga'-ston. Vol. 39a of Gedan Sungrab Minyam Gyunphel Series, *The Collected Works of Gung-thang dKon-mchog-bstan-pa'i-sgron-me.* Reproduced from the Lha-sa blocks by Ngawang Gelek Demo. New Delhi, 1975, Vol. Ja (8), ff. 110–143.

——————. *Khro-bcu'i bsrung-'khor rdo-rje'i go-khrab ngar-ma'i rno-mtshon-dang bcas-pa.* Lhasa edition, n.d.

——————. *Maṇḍal-gyi khrid-yig dpag-bsam snye-ma.* Vol. 36 of Gedan Sungrab Minyam Gyunphel Series, *The Collected Works of Gung-thang dKon-mchog-bstan-pa'i-sgron-me.* Reproduced from the Lha-sa blocks by Ngawang Gelek Demo. New Delhi, 1973, Vol. Nga (4), ff. 5–49.

dGe-'dun-rgya-mtsho. *rGyal-po chen-po rnam-thos-sras-la mchod-gtor 'bul-ba'i rim-pa dngos-grub-kyi bang-mdzod.* After a manuscript edition from rNam-rgyal grva-tshang, Dharamsala, 1969.

(bLa-ma Rin-po-che) lCe-sgom-rdzong-pa. *Man-ngag rin-po-che spungs-pa.* Published by Mongolian Lama Guru Deva, New Delhi, 1971.

'Jam-dbyangs bLo-gter-dbang-po. *rGyud-sde kun-btus* [*Texts Explaining the Significance, Techniques, and Initiations of a Collection of One Hundred and Thirty Two Mandalas of the Sa-kya-pa Tradition, Edited by 'Jam-dbyangs Blo-gter-dbang-po under the inspiration of his guru 'Jam-dbyangs Mkhyen-brtse'i-dbang-po*]. Reproduced photographically from the xylograph print set of the Sde-dge edition belonging to Thartse Rinpoche of Ngor. I–XXIX. Delhi, 1971.

——————. *bCom-ldan-'das rdo-rje mi-'khrugs-pa'i dkyil-'khor-du slob-ma dbang-bskur-ba'i cho-ga gzhan-phan zla-snang.* In *rGyud-sde kun-btus,* II, ff. 464–488.

——————. *mNyam-med jo-bo chen-po-nas brgyud-pa'i rdo-rje mi-'khrugs-pa mchog-gi sprul-sku lha-dgu'i dbang-tho las-sgrib rnam-sbyong zhes-bya-ba.* In *rGyud-sde kun-btus,* II, ff. 489–492.

Paṇ-chen bLa-ma VI, bLo-bzang-thub-bstan-chos-kyi-nyi-ma. *bKra-shis rdzas-rtags-kyi bshad-pa khag-cig.* In *The Collected Works of the Sixth Paṇchen Lama Blo-bzang-thub-bstan-chos-kyi-nyi-ma.* Reproduced from a print from the bKra-shis-lhun-po blocks by lHa-mkhar Yongs-'dzin bsTan-pa-rgyal-mtshan. New Delhi, 1974, Vol. Na (12).

——————. *Tshe-ring ljongs-drug-gi dpal-yon-la bstod-pa.* In *The Collected Works of the Sixth Paṇchen Lama Blo-bzang-thub-bstan-chos-kyi-nyi-ma.* Reproduced from a print from the bKra-shis-lhun-po blocks by lHa-mkhar Yongs-'dzin bsTan-pa-rgyal-mtshan. New Delhi, 1973, Vol. Kha (2).

Pha-bong-kha-pa Byams-pa-bstan-'dzin-'phrin-las-rgya-mtsho. *rNam-grol lag-bcangs-su gtod-pa'i man-ngag zab-mo tshang-la ma-nor-ba mtshungs-med chos-kyi rgyal-po'i thugs-bcud byang-chub lam-gyi rim-pa'i nyams-khrid-kyi zin-bris gsung-rab kun-gyi bcud-bsdus gdams-ngag bdud-rtsi'i snying-po* [A detailed presentation of Tsong-kha-pa's *Lam-rim chen-mo;* oral lectures edited by Khri-byang

Rin-po-che in 1957]. Reproduced from a tracing from a print on the bKra-shis-chos-gling blocks. In *The Collected Works of Pha-bong-kha-pa Byams-pa-bstan-'dzin-'phrin-las-rgya-mtsho*. Reproduced under the guidance of the Ven. Khri-byang Rin-po-che from the surviving manuscripts and prints from the Lhasa blocks by Chophel Legdan. New Delhi, 1974, Vol. 11.

——————. *bLa-ma mchod-pa'i cho-ga-la brten-nas zhing-dam-par mkha'-'gro'i brtan-bzhugs 'bul-tshul lhan-thabs-su bkod-pa bzhugs-so*. Blockprint by the Council of Religious and Cultural Affairs, Dharamsala.

Bod-ljongs mTsho-sngon Zi-khron Kan-su'u Yun-nan Shin-cang gi 'phrod-bsten-cus nas bsgrigs. *Bod-sman-gyi tshad-gzhi*. 1979 lo deb-gnyis-pa. mTsho-sngon mi-rigs dpe-skrun-khang.

(Dagyab) Brag-g.yab, L. S. *Bod-brda'i tshig-mdzod: Tibetan dictionary*. Printed and published by Rev. Lama L. S. Dagyab, Dharamsala, 1966.

Brag-ri sPrul-ming-pa bLo-bzang-lung-rigs-rgya-mtsho-dbang-rgyal. *rDo-rje-'chang pha-bong-kha-pa bde-chen snying-po dpal-bzang-po'i phyag-bzhes gtor-ma brgya-rtsa gtong-tshul-gyi man-ngag nag-'gros-su bkod-pa sku-gsum nor-bu 'dren-pa'i mchod-sbyin 'phrul-gyi shing-rta*. In *The Collected Works of Pha-bong-kha-pa Byams-pa bstan-'dzin 'phrin-las rgya-mtsho*. Reproduced under the guidance of the Ven. Khri-byang Rin-po-che from the surviving manuscripts and prints from the Lhasa blocks by Chophel Legdan. New Delhi, 1973, Vol. 5, ff. 500–528.

'Brum-ston rGyal-ba'i-'byung-gnas. *Jo bo rje dpal-ldan a-ti-sha'i rnam-thar rgyas-pa yongs-grags*. In *Kadam Pacho*, Part I. Reproduced from Lhasa xylograph pre-served in Sikkim Research Institute of Tibetology. Published by Director, Sikkim Research Institute of Tibetology, Gangtok and Calcutta, 1977.

Tsong-kha-pa bLo-bzang-grags-pa. *rJe thams-cad mkhyen-pa tsong-kha-pa chen-po'i bka'-'bum thor-bu*. In *The Collected Works (gsung 'bum) of the Incomparable Lord Tsong-kha-pa Blo-bzang-grags-pa*. Reproduced from prints from the 1897 Lhasa old-zhol (dGa'-ldan-phun-tshogs-gling) blocks, New Delhi, 1978, Vol. 2.

——————. *dPal gsang-ba 'dus-pa mi-bskyod rdo-rje'i dkyil-'khor-gyi cho-ga dbang-gi don-gyi de-nyid rab-tu gsal-ba*. In *The Collected Works (gsung 'bum) of the Incomparable Lord Tsong-kha-pa Blo-bzang-grags-pa*. Reproduced from prints from the 1897 Lhasa old-Zhol (dGa'-ldan-phun-tshogs-gling) blocks, New Delhi, 1978, Vol. 5.

Yongs-'dzin Khri-zur Byang-chub-chos-'phel. *dPal-ldan stod-rgyud lugs-kyi rab-gnas dge-legs char-'bebs-kyi ngag-'don phyogs-bsgrigs gsal-byed me-long*. Blockprint from Lhasa, microfilm held by Zentralasiatisches Seminar Bonn from a copy in the possession of rGyud-stod-grva-tshang, Bomdila, India, n.d.

Ratnaśila. *rDo-rje rnam-par 'joms-pa zhes-bya-ba'i [gzungs] dkyil-'khor-gyi lag-len*

go-rims ji-lta-ba zhes-bya-ba (*Vajravidāranā-nāma-dhāranī-mandala-prakriyā-yathākramanāma*). P3765, Vol. 79.

Sumatiratna. *Bod-hor-kyi brda-yig min-gcig don-gsum gsal-bar byed-pa mun-sel sgron-me*. In *Corpus scriptorum mongolurum*, instituti linguae et litterarum comiteti scientiarium et educationis altae reipublicae populi mongoli, Tomus VI, Oulan-bator, 1959.

A-khu Shes-rab-rgya-mtsho, *Grub-chen lū-i-pa'i lugs-kyi dpal 'khor-lo sdom-pa'i bskyed-rim he-ru-ka'i zhal-lung*. Blockprint. Lhasa Zhol edition, 1943, Vol. Kha. (2).

ABOUT THE AUTHOR

LODEN SHERAP DAGYAB RINPOCHE was born in Tibet in 1939. At the age of six, he was recognized as the reincarnation of the previous Dagyab Rinpoche and enthroned as the temporal and spiritual head of Dagyab State, Kham, East Tibet. He studied Buddhist philosophy and theology at Drepung Monastic University where he received additional intensive training from the Dalai Lama's tutors. In 1959, as a result of the Chinese occupation of Tibet he escaped from Tibet to India with the Dalai Lama. He continued his studies in Dharamsala, India and eventually received his geshe degree, the equivalent to a doctorate in philosophy and theology.

In 1966, Loden Sherap Dagyab Rinpoche emigrated to Germany. Today, a citizen of Germany, Loden Sherap Dagyab is a faculty member of the University of Bonn where he has been a research fellow and lecturer in Tibetan and Buddhist studies for nearly thirty years. He travels extensively, participating in international conferences on Tibetan studies and lecturing at numerous universities and Buddhist learning centers worldwide. Along with his position at the University, he serves as spiritual head of the Chödzong Buddhist Center in Germany.

A prolific writer, Loden Sherap Dagyab Rinpoche is the author of numerous books, articles, and translations ranging in subject from Tibetan language to Tibetan religious art and iconography.

WISDOM PUBLICATIONS

WISDOM PUBLICATIONS is a non-profit publisher of books on Buddhism, Tibet, and related East-West themes. We publish our titles with the appreciation of Buddhism as a living philosophy and the special commitment of preserving and transmitting important works from all the major Buddhist traditions.

If you would like more information, a copy of our mail order catalogue, or to be kept informed about our future publications, please write or call.

WISDOM PUBLICATIONS
361 Newbury Street
Boston, Massachusetts 02115
USA
Telephone: (617) 536-3358
Fax: (617) 536-1897

THE WISDOM TRUST

AS A NON-PROFIT publisher, Wisdom is dedicated to the publication of fine Dharma books for the benefit of all sentient beings. We depend upon sponsors in order to publish books like the one you are holding in your hand.

If you would like to make a donation to the Wisdom Trust Fund to help us continue our Dharma work, or to receive information about opportunities for planned giving, please write to our Boston office.

Thank you so much.

WISDOM PUBLICATIONS is a non-profit, charitable 501(c)(3) organization and a part of the Foundation for the Preservation of the Mahayana Tradition (FPMT).

CARE OF DHARMA BOOKS

DHARMA BOOKS CONTAIN THE TEACHINGS of the Buddha; they have the power to protect against lower rebirth and to point the way to liberation. Therefore, they should be treated with respect—kept off the floor and places where people sit or walk—and not stepped over. They should be covered or protected for transporting and kept in a high, clean place separate from more "mundane" materials. Other objects should not be placed on top of Dharma books and materials. Licking the fingers to turn pages is considered bad form (and negative karma). If it is necessary to dispose of Dharma materials, they should be burned with care and awareness rather than thrown in the trash. When burning Dharma texts, it is considered skillful to first recite a prayer or mantra, such as OM, AH, HUNG. Then, you can visualize the letters of the texts (to be burned) absorbing into the AH, and the AH absorbing into you. After that, you can burn the texts.

These considerations may also be kept in mind for Dharma artwork, as well as the written teachings and artwork of other religions.